IMAGES OF DEPRESSION-ERA LOUISIANA

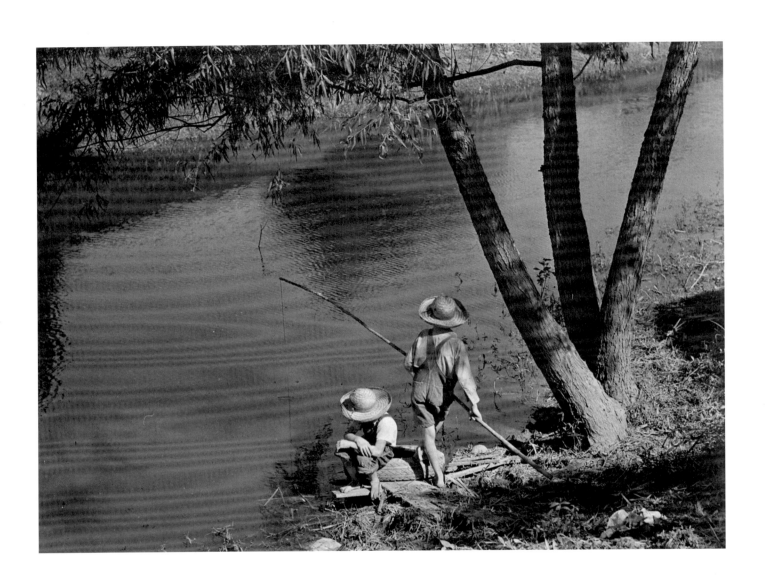

IMAGES OF DEPRESSION-ERA LOUISIANA

THE FSA PHOTOGRAPHS OF BEN SHAHN / RUSSELL LEE / MARION POST WOLCOTT

Bryan Giemza and Maria Hebert-Leiter

LOUISIANA STATE UNIVERSITY PRESS /// BATON ROUGE

Published by Louisiana State University Press
Copyright © 2017 by Louisiana State University Press
All rights reserved
Manufactured in Canada
FIRST PRINTING

Map created by Mary Lee Eggart

DESIGNER: Michelle A. Neustrom
TYPEFACES: Cassia, text; Cervo Neu, display
PRINTER AND BINDER: Friesens Corporation

LIBRARY OF CONGRESS CATALOGING-IN-PUBLICATION DATA

Names: Shahn, Ben, 1898–1969 | Lee, Russell, 1903–1986, | Wolcott, Marion Post, 1910–1990 |
 Giemza, Bryan Albin, editor. | Hebert-Leiter, Maria, editor. | United States. Farm
 Security Administration.
Title: Images of Depression-era Louisiana : the FSA photographs of Ben Shahn, Russell Lee,
 and Marion Post Wolcott / [edited by] Bryan Giemza and Maria Hebert-Leiter.
Description: Baton Rouge : Louisiana State University Press, 2017. | Includes bibliographical
 references and index.
Identifiers: LCCN 2017005936 | ISBN 978-0-8071-6795-3 (cloth : alkaline paper) | ISBN 978-0-
 8071-6796-0 (PDF) | ISBN 978-0-8071-6797-7 (ePub)
Subjects: LCSH: Louisiana—History—20th century—Pictorial works. | Depressions—1929—
 Louisiana—Pictorial works. | New Deal, 1933–1939—Louisiana—Pictorial works. | Louisiana—
 Rural conditions—Pictorial works. | Louisiana—Social life and customs—20th century—
 Pictorial works. | Louisiana—History, Local—Pictorial works. | Documentary photography—
 Louisiana. | United States. Farm Security Administration—Photograph collections.
Classification: LCC F375 .S53 2017 | DDC 976.3/0630222—dc23
LC record available at https://lccn.loc.gov/2017005936

The paper in this book meets the guidelines for permanence and durability of the Committee
on Production Guidelines for Book Longevity of the Council on Library Resources. ♾

To the People of Louisiana—Past, Present, and Future

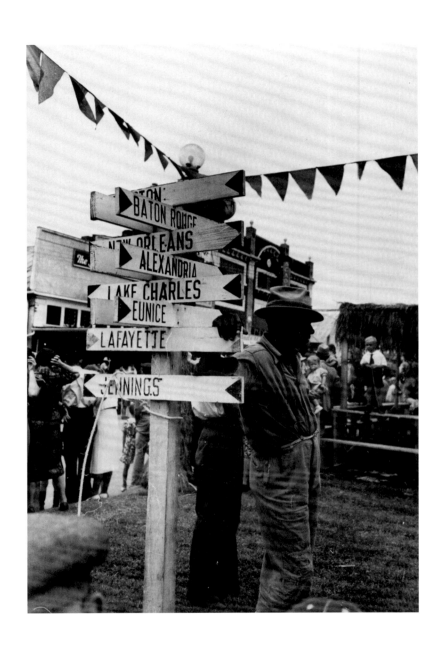

CONTENTS

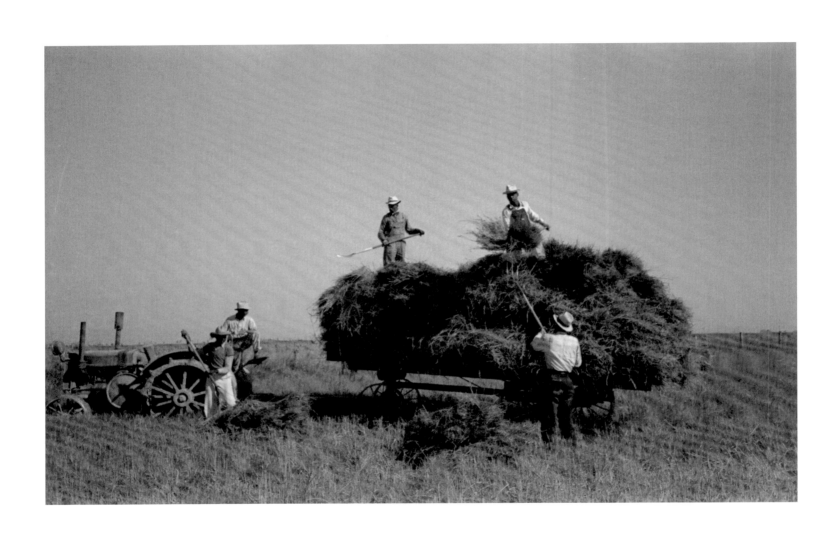

PREFACE

BETWEEN 1935 AND 1943, Roy E. Stryker sent photographers across the United States to take photos that testified to the need for federal assistance in mostly rural areas; serving those areas was the focus of the Farm Security Administration (FSA) and its predecessor, the Resettlement Administration (RA). Cities were photographed as well, especially after the formation of the Office of War Information (OWI) in 1942, when the government's priority turned from Great Depression recovery aid to war efforts. In some respects, Stryker's photo documentation program was a finest hour, a convergence of talent, leadership, and dedicated vision that resulted in one of the most impressive photo collections available to the general public.

Though the entire FSA/OWI Collection deserves to be celebrated—it includes over 170,000 negatives—this book features 168 of those images, most taken by Ben Shahn, Russell Lee, and Marion Post Wolcott, the three FSA photographers who spent more time and took more photographs in Louisiana than any of the other photographers. Lee and Wolcott took hundreds of photographs in the state, and their work offers a thorough visual account of it at the time. Letters to and from Lee and Wolcott, as well as government documents pertaining to Shahn's subject matter in Louisiana, provide deeper insight into the photographers' reactions to people, traditions, and everyday life in the Pelican State. Other FSA photographers' work, though no less interesting than that of these three principal photographers, is not included in this volume beyond a handful of representative images, because their documentary output in Louisiana was much more modest. And because the FSA era is the primary focus of this book, the work of OWI photographers in the state is only touched on.

While the story of Stryker and the photographers is one of conviction, the images included here offer their own stories—of perseverance, of faith, and even of celebration. The introduction that follows explains the RA and FSA programs and their purpose; explores the reasons why Stryker chose photography as his medium of expression; sketches the professional backgrounds of Shahn, Lee, and Wolcott; and analyzes the operation of Stryker's program and the federal projects in Louisiana documented by his photographers. The photo gallery includes 147 images taken by Shahn, Lee, and Wolcott as they crossed the state and that continue to teach and inspire us today.

We could not have completed this volume without the aid of certain librarians and scholars. In order to piece together the stories of the Historical Section, the FSA at large, and the photographers themselves, we turned to various collections. We appreciate all of the help and direction we received from the librarians at UNC Library (especially Tommy Nixon), the Smithsonian Archives of American Art, Middleton Library at Louisiana State University, and Snowden Library at Lycoming College (especially Karla Procopio) in accessing and borrowing Roy Stryker's papers. Thanks are also due to Wolfgang Wimmer (Zeiss Company) and Deborah Mohr (George Eastman Museum Library) for responding quickly and thoroughly to our queries. We thank Lynn Estomin for also responding to queries on the history of photography. Finally, we would like to especially thank Margaret Lovecraft without whose editorial and insightful vision, this book would not be what it is today.

IMAGES OF DEPRESSION-ERA LOUISIANA

NEW DEAL AGENCIES AND PROGRAMS

1933

* Agricultural Adjustment Act and the Agricultural Adjustment Act of 1938 (AAA), 1933–today
* Civilian Conservation Corps (CCC), 1933–1942
* Civil Works Administration (CWA), 1933–1934
* Federal Emergency Relief Administration (FERA), 1933–1935
* Glass-Steagall Act/1933 Banking Act, included the Federal Deposit Insurance Corporation (FDIC), 1933–today
* Home Owners' Loan Corporation (HOLC), 1933–1951
* National Industrial Recovery Act (NIRA), 1933–1943
* Public Works Administration (PWA), 1933–1944
* Tennessee Valley Authority (TVA), 1933–today

1934

* Federal Housing Administration (FHA), 1934–today
* The Wheeler-Howard Act or the Indian Reorganization Act (IRA), 1934–today
* Securities and Exchange Commission (SEC), 1934–today

1935

* Federal Project Number One, 1935–1943
* Federal Art Project (FAP), 1935–1943
* Federal Music Project (FMP), 1935–1939
* Federal Theatre Project (FTP), 1935–1939
* Federal Writers' Project (FWP), 1935–1939
* National Youth Administration (NYA), 1935–1939
* Resettlement Administration (RA), 1935–1937
* Rural Electrification Administration (REA), 1935–today
* Social Security Act (SSA), 1935–today
* Wagner Act or National Labor Relations Act (NLRB), 1935–today
* Works Progress Administration (WPA, which replaced FERA), 1935–1943

1937

* Farm Security Administration (FSA), 1937–1944
* United States Housing Authority (USHA), 1937–1947

1939

* Federal Security Agency (FSA), 1939–1953

THE MAKING OF VISUAL HISTORY

The RA, FSA, and New Deal: A Brief Overview

The fascinating story of the Farm Security Administration (FSA; 1937) photographers begins with Franklin D. Roosevelt's first administration and the passing of laws and executive orders that constituted the New Deal. To counteract the fallout of the Great Depression, Roosevelt gathered trusted economic advisors to develop policy recommendations with the goal of supporting the nation's recovery. The first step was shoring up the financial system with the Emergency Banking Act of 1933. By 1935, more programs and acts emerged to address the continuing effects of the Depression. Rexford Tugwell was but one advisor who served on what would come to be called Roosevelt's "Brain Trust." This group brainstormed ways to address poverty and unemployment through initiatives such as the Civilian Conservation Corps (CCC; 1933), the Tennessee Valley Authority (TVA; 1933), the Works Progress Administration (WPA; 1935), and the Rural Electrification Administration (REA; 1935).

Another such program, the Resettlement Administration (RA), was Tugwell's brainchild. Formed in 1935 by Executive Order 7027, the short-lived project encouraged struggling families to relocate to communities planned and run by the federal government, and would come to include large camps for Dust Bowl migrants. The Information Division was a subset of this administration, created specifically to distribute information that would engender support for the federal programs and acts being introduced by the New Deal. The Historical Section, a subdivision of the Information Divi-

sion, was also created in 1935 to record the need for federal funding of such programs through sociological documentation, including photographs. Tugwell didn't have to look far when hiring the chief for this new section, finding the perfect leader in the cohort of his former students.

Originally from the area around Montrose, in western Colorado, Roy E. Stryker served in World War I before marrying and moving to New York City, where he began his undergraduate studies in economics at Columbia University in 1921. There, he was greatly influenced by Tugwell and John Coss, whose "Contemporary Civilization" course was enhanced with excursions to museums and other educational institutions in the city (Hurley 1972, 10). Stryker completed his undergraduate degree and continued his graduate studies there with the intention of earning his PhD. During his teaching apprenticeship as a graduate student, Stryker continued Coss's example of taking students on field trips, encouraging them to experience the economic workings of the nation by attending labor meetings and even joining picket lines when the union men invited them to do so (11). In fact, Stryker enjoyed teaching so much that he never completed his doctoral degree in economics. He did, however, help Tugwell complete *American Economic Life and the Means of its Improvement,* first published in 1925. This study, complete with photographs, was initially published for use by Columbia students as a textbook for the "Contemporary Civilization" course and planted the seeds for the FSA Collection now housed in the Library of Congress (14). Tugwell emphasized the centrality of "descriptive economics" that provided students with visual context

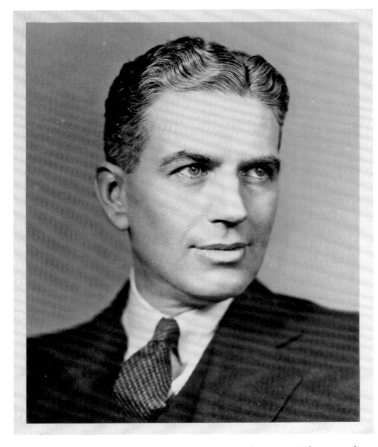

FIG. 1. "Rexford G. Tugwell, administrator, Resettlement Administration" (1935–1942).

ment efforts, and in that respect, a picture really was worth a thousand words. As Hurley writes, "Tugwell wanted someone who knew how to use pictures, both as a record of the project's activities and as a method of gaining national acceptance of the new programs" (Hurley 1972, 28). In a letter dated July 6, 1935, Stryker made his career decision official: "I have decided to drop out of Columbia College to go down and work with Professor Tugwell in Washington" (Stryker, LSU, reel 1). And so he resigned his appointment as Associate in Economics and left graduate school and college teaching behind. It was an audacious move, but then turbulent times called for strong measures. In a time when Americans were willing to acknowledge the limitations of traditional governance—after all, it had neither forestalled an economic crash or cured its ills—the marketplace of ideas remained open.

With a measure of understatement, the 1935 Annual Report for the Historical Section observes, "In setting up a photographic section the Resettlement Administration departed somewhat from conventional procedure" (Stryker, Smithsonian, no. 24). To justify the purpose of the section, the report notes the agency's reach into "the press, the literature, and the art circles of the United Sates, [is] unprecedented in any other photographic agency." Furthermore, the section's "historical and documentary function is fulfilled not only in keeping a record of the administration's projects, but also in perpetuating photographically certain aspects of the American scene which may prove incalculably valuable in time to come" (no. 24). Time has indeed proven the value of this record of the nation during the Great Depression, thanks in large part to Stryker.

During his years as chief of the section, Stryker witnessed the resignation of Tugwell in 1936, as the RA was roundly criticized in Washington, DC, on the basis of sustainability and cost-effectiveness. Furthermore, conservatives in the federal government found him "too radical and branded several of his Resettlement Administration programs socialistic as soon as they began" (Fleischhauer and Brannan 3). As a result of backlash, the program was restructured into the FSA and absorbed by the United States Department of Agriculture, rather than operating as the autonomous program it had been. Despite the change in name to the FSA, the program maintained its service to poor rural populations. Under Stryker, the Historical Section continued to raise the plight of farmers—now being alleviated through various federal programs—to a national audience. The photographers took thousands of photographs, some of which were published in *Life* and *Look* magazines, news-

for economic principles and policies at work, a lesson Stryker continued to follow throughout his life (10). According to F. Jack Hurley, "[M]agazines of the day, *Vogue, Vanity Fair,* and others used photographs to present an idealized view of life as it ought to be, rather than life as it was" (12). Tugwell and Stryker sought to change that and to fulfill the purpose of the federal programs by "show[ing] the nation its rural problems" (viii).

Stryker first joined Tugwell in Washington, DC, during the summer of 1934 as part of the Information Division of the Agricultural Adjustment Administration (AAA), which offered farmers subsidies to decrease production levels and thus increase the market value of foodstuffs. During the summer of 1935, once Tugwell's RA was formed, Stryker was offered a permanent position in the Historical Section. Tugwell recognized the importance of winning public support for government-sponsored resettle-

papers, and books, including Sherwood Anderson's *Home Town* (1940) and Richard Wright's *12 Million Black Voices* (1941).

While Stryker sent his photographers across the nation, the Federal Writers' Project (FWP; 1935), a division of the Works Project Administration (WPA), hired writers, editors, historians, and cartographers, among others, to create written records of contemporary America. Two noted collections resulting from their work are the American Guide Series, which includes forty-eight state guides along with guides for large cities and regions, as well as the Slave Narrative Collection, which is comprised of the oral histories of the last generation of slaves. The WPA also dispatched FWP employees to conduct folklife surveys and record songs, folktales, and traditions around the nation. Notable folklorists from the WPA cohort include Zora Neale Hurston (1891–1960), John A. Lomax (1867–1948), Alan Lomax (1915–2002), and Lyle Saxon (1891–1946).

With the coming of World War II, the federal government turned its focus to military preparation and created the Office of War Information (OWI) in 1942. Throughout this time, Stryker concentrated on the role of photography in documenting a rapidly changing nation. He continued to send his photographers across the United States. Many of the photographs were never published, though they are among the approximately 176,000 negatives retained by the Library of Congress.

Ben Shahn, Russell Lee, and Marion Post Wolcott

Of the three photographers showcased in this book, Ben Shahn (1898–1969) was the first to visit Louisiana. Born in a Lithuanian shtetl, he emigrated with his parents to New York when he was eight. In the spring of 1925, he and his first wife, Tillie Goldstein, traveled throughout North Africa and Europe, including stops in Florence, Venice, Vienna, and Paris, where Shahn studied painting (Greenfeld 40). While this tour exposed him to more of the world, his experience of the United States, outside of New York, was limited. By his own admission, his "knowledge of the United States rather came via New York and mostly through Union Square" (Shahn interview). "When I began to go out into the field, it was a revelation," Shahn told Richard Doud, who interviewed him in 1964 for the Archives of American Art. Shahn's statement reminds us that his first exposure to the South came with his work behind

the camera and that he learned much about the realities of American life, outside of New York City, during his travels.

Shahn's 1935 Mississippi River delta tour offered him a series of firsts: his first work for the FSA, his first concerted attempt to shift his artistry to photography, his first extended trip with a girlfriend who would become his second wife, and his first significant experience of American folklife outside of the northeast. He seemed energized from the outset. Shahn received his FSA appointment letter on September 16, 1935, with his first day of work coming three

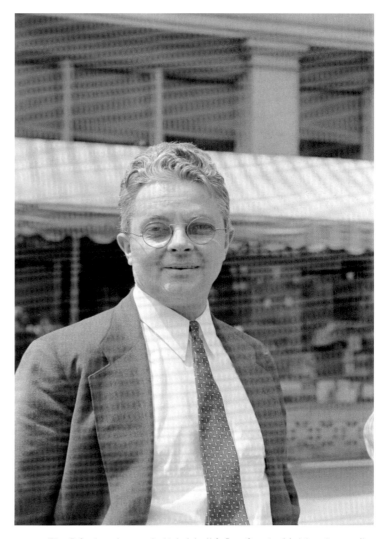

FIG. 2. "Roy E. Stryker, photograph chief of the U.S. Farm Security Administration standing in street, probably in Washington, DC." Russell Lee, Aug. 1938.

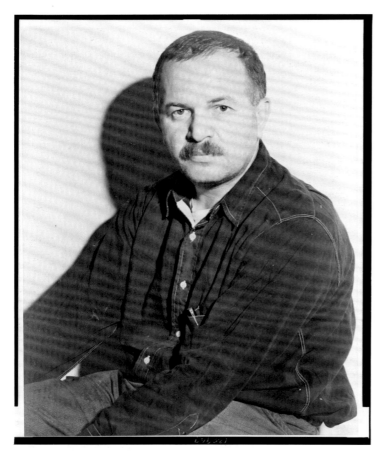

FIG. 3. "Ben Shahn, Farm Security Administration photographer, half-length portrait, seated, turned to the left, full face." Dec. 12, 1938.

days later. He was furnished with his list of RA contacts on September 23, and in October he crisscrossed the country, photographing scenes in Pennsylvania, West Virginia, Kentucky, Tennessee, Arkansas, Mississippi, and Louisiana! Shahn's papers include a telegram dispatching him to what would prove a tense meeting with Arkansas's antilabor senator, Joseph Robinson (Shahn Papers, Oct. 7), as well as his Little Rock hotel bill (Oct. 10–17). Shahn's Mississippi images were shot around Natchez, and he apparently made a brief stop in Woodville, not far from the Louisiana state line. Biographer Howard Greenfeld notes that Shahn returned to Washington, DC, on November 8, 1935, where he deposited thirty-two rolls of 35-millimeter film and nine rolls of 16-millimeter movie film.

Even though he was an outsider, Shahn possessed a native charisma and openness that went a long way toward winning the trust of his subjects in the South. In addition, he employed a technique that allowed images to appear more natural. "I used what is called an angle finder," he explained in an interview with Doud. "Now, I would look this way and by refraction of what they call an angle finder I would take away any self-consciousness they had. So, most of my pictures don't have any posed quality and this was a very helpful thing in the whole quality of my work, this angle finder" (Shahn interview). This angle finder allows the photographer to appear to be pointing the camera away from the subject while the mirror and prism of the angle finder captures the subject in full while standing off to the side. Thus, Shahn did not have to stand directly in front of his subjects to get the desired photograph. Nor did he allow bulky camera relays or flash to detract from the human connection by making his purpose obvious and his subjects more conscious. Indeed, Shahn biographer Howard Greenfeld describes Shahn's camera as "flat enough to carry unobtrusively in his back pocket" (Greenfeld 120). Shahn relished these approaches, which reduced the self-consciousness of his subjects, early on, and would recall how the first time he visited Louisiana, "some kids got around talking to me and they didn't know if that was a camera or a machine gun" (Shahn interview).

When he returned to photograph more of the state in 1937, the natural, unposed images Shahn preferred would be harder to achieve, since by then word had traveled around that the FSA photographers were publishing photos not just in federal documents but in national magazines as well. Self-consciousness does not necessarily efface the stories or the life-narratives suggested in the images, however. And Shahn always maintained he believed the image itself, regardless of quality, was important, which is perhaps the reason he turned to photography when he found his "own sketching was inadequate" (Shahn interview). He would come to see photography as a companion to other artistic endeavors and a means of improving his murals (Shahn interview).

Unlike Russell Lee and Marion Post Wolcott, Shahn worked for the Special Skills Division, not the Historical Section. While also under the direction of the RA, and later the FSA, this division was dedicated to creating murals, posters, pamphlets, and other materials to promote the need for and work of the federal programs (Shahn interview). In his interview with Doud, Shahn said, "I did some drawing and did a lot of photography but I was not part of Stryker's outfit at all I presented them as a gift with my negatives and I also, for that reason, had the facilities to print them" (Shahn

interview). Shahn had been exposed to photography earlier in his career when he shared a studio with Walker Evans. Deciding to take up photography to improve his painting, Shahn asked his brother to buy a 35 mm Leica camera for him, since that was the kind Evans favored. When he asked Evans to teach him how to use it properly, Evans responded, "It's very easy, Ben. F9 on the sunny side of the street, F4.5 on the shady side of the street. For a twentieth of a second hold your camera steady" (Shahn interview). Despite Evans's simplistic instructions, Shahn inevitably learned much from field experience, as did all of the FSA photographers.

/ / /

In contrast to Shahn, Russell Lee (1903–1986) came from a wealthy family of farmers in Ottawa, Illinois. He graduated from Lehigh University in chemical engineering, yet he walked away from a comfortable job as a chemist for CertainTeed Products in 1929 to become a painter. The freedom to make this choice was underwritten by an inheritance from his granduncle's farms (Hurley 1978, 12). Eventually, Lee moved to the artist community at Woodstock, New York, and in 1935 bought his first camera, a 35 mm Contax. Before joining Stryker's team, he used his knowledge of chemistry to "push" the normal film speed rating from ASA 32 to ASA 100, so that he could photograph in lower light (13). As F. Jack Hurley writes, Lee "loved the technical aspects of the work" (13), and he incorporated his engineer's training into his photography in Louisiana and elsewhere.

It was Shahn who brought Lee, indirectly, into Stryker's circle; Lee was sufficiently impressed after meeting Shahn at the American Artists' Congress in 1936 that he too applied for an FSA job. Lee outpaced Shahn in terms of volume: some 19,000 of the approximately 63,000 captioned photographs in the Library of Congress FSA series are credited to him, versus 2,827 credited to Shahn, of which only 187 were taken in Louisiana. In contrast, Lee took over 1,600 pictures in the Pelican State. After joining Stryker's team, he also used a Super Ikonta B with its coupled rangefinder, a camera that "featured an auto framing mechanism that banished the need to precisely wind the film" (Elek). While the film format for 35 mm cameras was 24x36 mm, the Super Ikonta B version was specifically designed for 6x6 cm. Armed with his cameras, Lee traveled to Louisiana in 1938, taking photographs in Donaldsonville, Pilottown, Crowley, and Transylvania, as well as New Orleans, where he

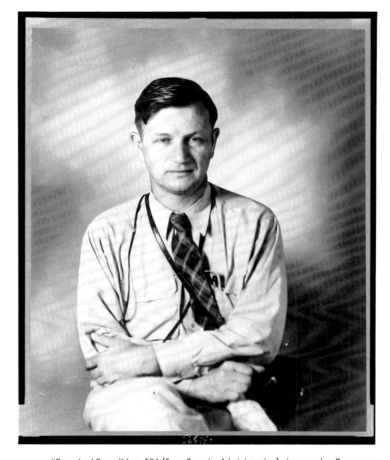

FIG. 4. "Portrait of Russell Lee, FSA (Farm Security Administration) photographer," ca. 1942.

met his second wife. In 1939, he returned, primarily photographing Louisiana strawberry pickers in a series of images that traced the operations of agribusiness in and around Hammond, from field to auctioneer to the packing crates of refrigerated cars. That 1939 series alone consists of 150 photographs. Shahn had taken a much smaller number of photographs of strawberry pickers in 1935.

Lee pursued his interest in capturing everything by using direct and multiple flash to photograph inside buildings during his years with the FSA. He employed this technique since "pushing" the film produced grainy images. Indeed, he brought new levels of exposure to homes that would otherwise see only the illumination of natural light or flame. On September 20, 1938, Lee wrote to Stryker, saying he "was able to get a lot of interior shots with Contax flash on the river trip. They include stores, barrooms,

dance halls" (Stryker, LSU, reel 1). The river he referred to was the Mississippi, and his photographs of the interiors of these stores, barrooms, and dance halls remain part of the Louisiana images included in the FSA/OWI Collection. Lee also photographed constantly and quickly, leading Stryker to describe him as an "analyzer, a thorough, fast operator, and he turned in quality and he turned in detail, and when he hit a thing he went through it from all phases and analyzed it and took it apart for you and laid it on the table," as is clearly shown by the 246 images taken at the 1938 Crowley Rice Festival (qtd. in Mora and Brannan 234).

Lee's dedication to capturing fine details benefitted from his careful preparation, an approach emphasized by Stryker, who stressed the importance of doing homework before going to a location. As he planned his many odysseys for the FSA, Lee borrowed

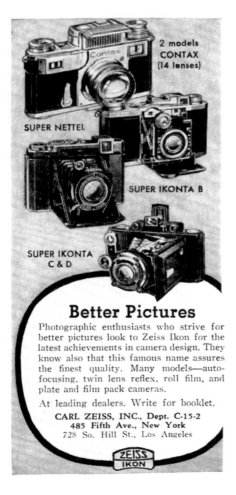

FIG. 5. A 1938 Zeiss advertisement featuring the cameras Russell Lee favored. Zeiss, named for Carl Zeiss (1816–1888), a German optician, was the largest camera producer during the second decade of the twentieth century.

Department of Commerce publications brimming with population statistics. He had also studied J. Russell Smith's 1925 book, *North America,* with its sweeping model of economic and geographic determinism. In fact, Stryker assigned reading to all of his photographers. In addition to Smith's work, Arthur Raper's *A Southerner Looks at the South* and *Preface to Peasantry* were required reading. In 1964, Lee recalled Stryker's emphasis on meticulous preparation: "Well, my first impression [of the FSA] was the importance of getting a good background about the area to be photographed. Because Roy immediately gave me about five books to read" (qtd. in Mitchell 3). Stryker also put Lee in touch with regional authority Lyle Saxon, whom Lee remembered as "a swell guy with a real knowledge of the state and an appreciation for documentation" (Stryker, LSU, reel 1, Sept. 13, 1938). Saxon wasn't the only local with whom Lee spoke. He described to Stryker how he took "a reconnaissance tour" and met with other Louisianians, seeking more information about the areas he planned to photograph. "In talking with several of the old-timers and well-informed around here they advise that it would be best to spend about 3 or 4 days simply getting known before attempting to take any pictures," he relayed. "Of course the name—government—is 'mud' over there" (qtd. in Mitchell 4).

/ / /

Born in Montclair, New Jersey, to a prominent family, Marion Post Wolcott (1910–1990) dedicated her photographic career to documenting the impact federal assistance programs had on the many societal issues exacerbated by the Great Depression, especially those related to racial inequality. While studying in Vienna, she met photographer Trude Fleischmann, who was instructing her sister and who encouraged Wolcott to try photography because she "had a good eye" (Brannan 2006). When the rise of Nazism made it too dangerous to remain in Vienna, the sisters returned home, and Wolcott continued to develop her photographic skills. She worked for the Philadelphia *Evening Bulletin,* where male coworkers regarded her with both lust and outright hostility. They "urinated in her photography chemicals, threw spitballs at her, and extinguished their cigarettes in her developing trays," writes Beverly W. Brannan in a Library of Congress biographical profile. "Claiming the other staff photographers were 'wolves,' each of them offered to look out for her" (qtd. in Brannan, citing Hendrickson, 40). When

Wolcott confronted them about their behavior, she earned a measure of grudging acceptance. Eventually Ralph Steiner, a photographer and avant-garde filmmaker of the 1930s who worked on the RA documentary *The Plow that Broke the Plains* (1936), showed her portfolio to Roy Stryker, who hired Wolcott at age twenty-eight in 1938. A 1940 photograph of her attached to her letter of introduction, which served as her official FSA credential, suggests something of her dauntless character, which served her well as she traveled alone (as she did during her time in Louisiana) to complete her work for the FSA.

Wolcott's way of working was similar to Lee's insofar as she preferred to take many photos. In fact, in a letter dated February 13, 1939, Stryker, now serving as her instructor, commented on her proclivity toward "too many exposures of a particular subject" (Stryker, LSU, reel 2). Also like Lee, Wolcott used the field as a classroom wherein Stryker was her primary teacher. While she commented on the lack of cooperation in certain towns, she also took advantage of local experts and developed a distinctive style by involving herself in the daily lives of her subjects. She did not shy from picking beans alongside tenant farmers or changing the dirty diapers of their children (Wolcott-Moore). Having joined the FSA in its later years, she photographed the poor and the wealthy, as she was instructed by Stryker to show both the continuing need for and success of the federal programs. Her ability to gain her subjects' trust allowed her to capture something of their losses and their hopes, their suffering and their determination. Her daughter, Linda Wolcott-Moore, explained how her mother's dedication influenced those she photographed: "She gave them hope; and, she did what she had to do, with a passion and commitment that kept her on the backroad alone for up to a month at a time." Marjorie Davison Sharp, a director of the Tower Hill School in Wilmington, Delaware, complimented Wolcott on her ability to "get such natural poses and as fine pictures" when Wolcott photographed the school (Stryker, LSU, reel 2, Jan. 30, 1940).

In turn, Wolcott's letters to Stryker often record her acerbic wit. For example, in 1939, when commenting on the contempt the residents of Belle Glade, Florida, harbored for the federal government, she compared them to the rattlesnakes in the area (Stryker, LSU, reel 2). The same sarcasm arose when she answered a letter from Stryker instructing her to wear skirts in the South. She opens the letter with "Now grandfather . . . ," and goes on to say, "Let us assume that we agree on the premise that all photographers need

FIG. 6. "Marion Post, principal photographer, Historical Section, Division of Information, head-and-shoulders portrait, facing slightly left, notarized photograph attached to letter of introduction 1940."

pockets—badly—& that female photographers look slightly conspicuous & strange with too many film pack magazines & rolls & synchronizers stuffed in their shirt fronts, & that too many filters & what nots held between the teeth prevent one from asking many necessary questions" (reel 2, Jan. 13, 1939). She then explains that after scouring every other store in the area she finally found suitable clothing in a drugstore. She wore slacks as often as possible but "learned you can't wear them in the stix" (reel 2), since the rural South remained more conservative in terms of gender assumptions and rules.

In Louisiana, Wolcott took some 900 photographs in both color and black and white. While traveling in the state, she commented on the terrible humidity, writing she finally understood why "people around New Orleans & Terrebonne, & south La. drink whiskey & black coffee fairly regularly during the day" since she also found the heat exhausting (Stryker, LSU, reel 2, July or Aug. 1940). Wolcott overcame the Deep South heat to make her own mark on the FSA collection, especially with her landscape photography. One of the most memorable images found in her Louisiana work is a color photo titled "Boys fishing in a bayou, Schriever, La." Perhaps if the heat of summer days could be captured, it is arrested in this pho-

FIG. 7. "Belle Grove Plantation, 1858. Louisiana." Walker Evans, ca. 1936.

tograph. The color process imbues it with hues that blur the lines between dream and reality, demonstrating the profound artistry of documentary photographers. (See Plate 125 in the gallery for the black-and-white version of this photograph.)

Other Photographers in Louisiana and the South

With the introduction of roll film in 1881 and the invention of George Eastman's first Kodak camera seven years later, millions of ordinary people could capture their own memories on film. This small fixed-focus camera that could be held in the hand encouraged amateur photographers to shoot images for personal consumption (Fineman). By 1927, the simple flashbulb—lighter, cleaner, and less dangerous than the flash powder it replaced—entered the market. These bulbs, however, were not cheap and so were used primarily by professional photographers.

With government funding and support at their disposal, various New Deal–program photographers were empowered to use the latest technology to produce a more comprehensive national portrait. For example, Wolcott wrote from Chapel Hill, North Carolina, about trying out a "new orange filter on the new Eastman film," and also asked if Lee had the Abbey flashgun installed (Stryker, LSU, reel 2, Oct. 2, 1939). Letters from the photographers to Stryker often relay information about equipment field tests: Stryker favored Superflash over GE flashbulbs and advised Wolcott that Agfa's Supreme brand of film was the best fast film for the Leica. The photographers sent requests for more flashbulbs and new equipment as needed, and in 1939 Clara Dean, who worked in the Historical Section's office, wrote to Lee, "Post Office Department has a new ruling that Superflash Bulbs cannot be mailed" because they "ignite if broken," though this was "not true of other flash bulbs" (reel 2, Jan. 20, 1939). Dean would have to send the bulbs by express freight instead.

While Shahn, Lee, and Wolcott took the majority of the Louisiana pictures included in the FSA/OWI Collection, other FSA photographers also traveled to the state to photograph its people and places. And, as innovative as Stryker's program was, the FSA photographers were hardly the only government employees collecting information in support of federally funded programs, nor were they the only ones photographing the nation at the time.

FSA PHOTOGRAPHERS WHO WORKED FOR OR IN CONJUNCTION WITH THE HISTORICAL SECTION

*John Collier, 1941–1943
*Jack Delano, 1940–1943
Walker Evans, 1935–1938
*Howard R. Hollem, 1941–1943
Theodore Jung, 1935–1936
*Dorothea Lange, 1935–1939
*Russell Lee, 1936–1943
Carl Mydans, 1935–1936
Arthur Rothstein, 1935–1940
Ben Shahn, 1935–1938
*John Vachon, 1937–1943
Marion Post Wolcott, 1938–1942

*These photographers continued to work for the federal government or else returned, as Lange did, to photograph war efforts as part of the Office of War Information, which was terminated in 1945.

Peter Sekaer, a Danish photographer who immigrated to the United States when he was a teenager and later worked for the Rural Electrification Administration (REA), the United States Housing Authority (USHA), and the OWI, took his own photographs of Louisiana for New Deal programs. Though he was never part of Stryker's team, he was an acquaintance of Ben Shahn, which is perhaps how he met Walker Evans, who became a close friend (Kahn). In fact, Sekaer accompanied Evans on his travels through the South in 1936, when Evans was photographing for the Historical Section files.

/ / /

On his trips to Louisiana, Walker Evans (1903–1975) captured approximately thirty FSA images around New Orleans and Belle Grove Plantation, almost all of them architecturally themed. He took other photographs in Louisiana in 1935–36, which are widely held at a variety of institutions, including the Walker Evans Archive at the Metropolitan Museum of Art. Some of the Louisiana images are on loan at the Ogden Museum of Southern Art in New Orleans.

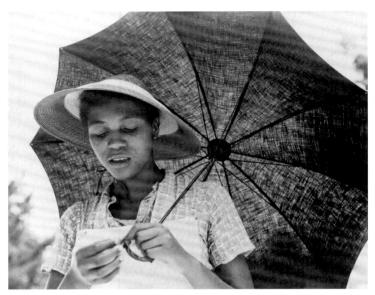
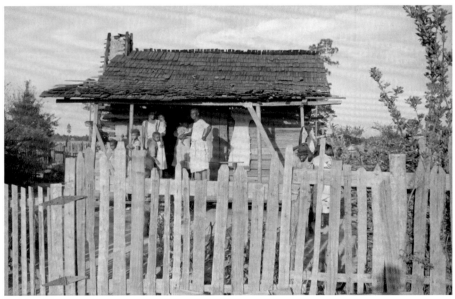

FIG. 8. "The one inhabitant remaining in Fullerton, Louisiana, an abandoned lumber town." Dorothea Lange, July 1937 (*left*).

FIG. 9. "Louisiana Negress." Dorothea Lange, July 1937 (*right*).

FIG. 10. "Negro rehabilitation client, Tangipahoa Parish, Louisiana." Arthur Rothsteir, Sept. 1935 (*bottom*).

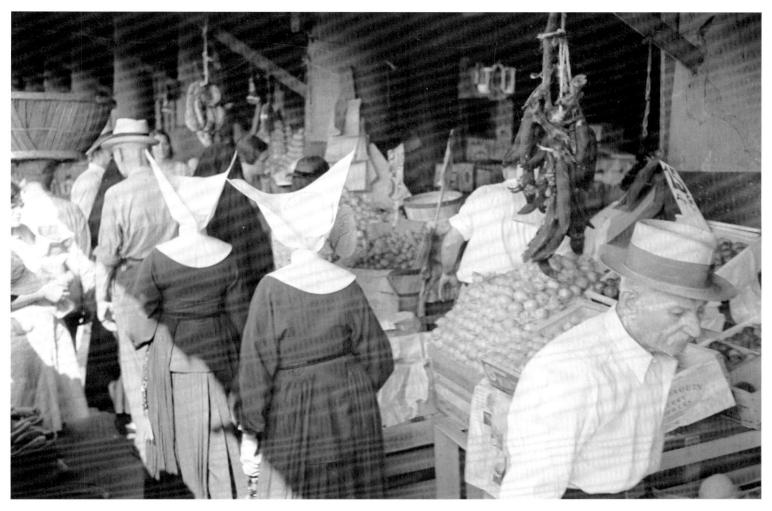

FIG. 11. "Marketplace in the French quarters of New Orleans, market for Resettlement Administration's rehabilitation clients." Carl Mydans, June 1936.

Dorothea Lange (1895–1965), another celebrated photographer remembered for her Dust Bowl–refugee images, passed through the state later, in July 1937, and approximately thirty of her photographs are in the FSA archive. Some are distinctively political in their import, such as "The one inhabitant remaining in Fullerton, Louisiana, an abandoned lumber town." Compare that man in the ruins with the resplendent "Louisiana Negress" in an aureole of light, whose portrait Lange composes so skillfully that it seems almost to suggest the presence of color—even in a black-and-white photo.

Other FSA photographers in the cohort included Arthur Rothstein (1915–1985), who followed Stryker, his former Columbia professor, into the Historical Section ranks, taking about seventy photographs in several parishes while visiting Louisiana in September 1935, when he was just twenty years old. Rothstein's talent shows in the deliberate way that he composed his photograph "Negro rehabilitation client, Tangipahoa Parish, Louisiana" to suggest enclosure, segregation, and poverty.

Carl Mydans (1907–2004) took around forty photographs in New Orleans and its vicinity during his June 1936 visit. His arresting image of the French Market is iconic for capturing the city's juxtaposition of the ordinary and the sacred in a site still recognizable to contemporary tourists.

Howard R. Hollem (?–1949) and John Vachon (1914–1975) were relatively late arrivals to Louisiana, traveling there in 1942 and 1943, respectively. They were commissioned by Stryker's newly formed OWI, and part of their work was to use then-new, high-quality color photography, along with black and white, to photograph aircraft factories, members of the armed forces, and even women in the workforce throughout the nation. With the advent of World War II, propaganda was suddenly not just acceptable but ubiquitous. Hollem's photograph of a lone coast guard sentry, pistol on his hip, is a reminder of the war that would wash up on the shores of the Gulf. Vachon may have been a propagandist, taking pictures certain to encourage support for the war, but the nuance of some of them extends beyond the party line, as demonstrated by the black-and-white image of a mother he photographed in Plaquemines Parish. She had sent three sons to the war front, leaving the viewer to wonder if the three stars on her service flag are blue or gold (blue indicating active service and gold indicating death during service)—and whether her black dress is her ordinary garb or an indication of mourning.

Vachon originally worked as an FSA photo filer in Washington, DC. Stryker would recall how he "came in and didn't know much of anything.... He and I had many a conversation together, talking about the future and what he might be able to do. I said, after all, 'When you do filing, why don't you look at the pictures? Pay atten-

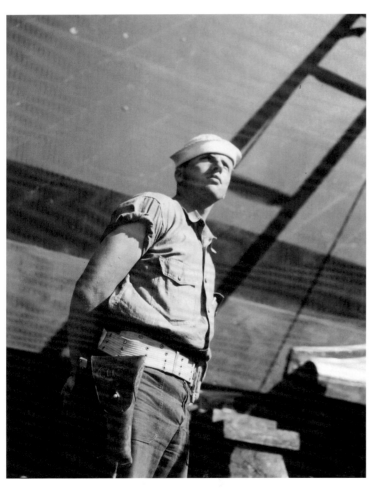

FIG. 12. "Coast Guardsman standing watch over 78-foot torpedo boat. Continual watch is kept." Howard Hollem, July 1942.

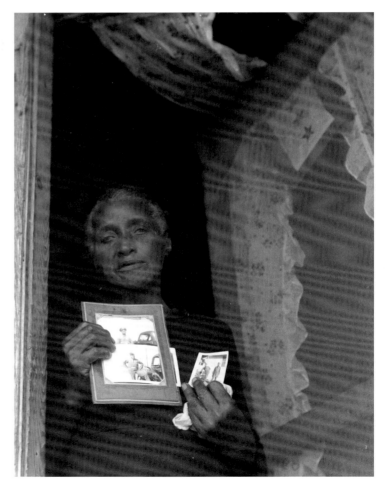

FIG. 13. "Placquemines [sic] Parish, Louisiana. Mother of three soldiers." John Vachon, June 1943.

tion to them. Get some idea, and if you ever decide that you want to take pictures, just remember, don't try to say, 'I'm going to take pictures like Russell Lee,' but say, 'I'm going to learn to take pictures.' Say, 'I've got some ideas'" ("Roy Stryker on FSA" 7). Vachon was also encouraged to take up photography by Ben Shahn. Like Shahn's work, Vachon's reveals the fingerprints of an artist with a common touch who consistently established a comfortable degree of intimacy with his subjects.

All of these other photographers, with the possible exception of Hollem, whose color war photography is gaining new viewers today, went on to careers of notable distinction in their own time. Critics continue to argue the relative merits of each, though few would dispute that their place in the American canon is secure. Historical thresholds are often arbitrary impositions, handed down with the benefit of hindsight and sometimes clouded by nostalgia. Regardless of their prominence, these photographers shared a common desire to capture on film the people and places of Louisiana at a time when the state and the nation encountered an uncertain future.

In addition to citizen-photographers and those hired by federal programs, other at-large photographers went about their work, sometimes commissioned, sometimes doing paid documentary work, and sometimes pursuing art for the sake of art itself. Clarence John Laughlin of Lake Charles (1905–1985), who worked in a surrealist mode, fits into this last category. Earl Samuel (E. S.) Martin (1910–1986), from Plattenville, Louisiana, worked for the WPA for a time and documented Franklin D. Roosevelt's 1937 visit to New Orleans. New Yorker Robert Tebbs photographed Louisiana plantation homes in the 1920s, and architectural photographer Richard Koch (1889–1971) of New Orleans worked in a similar vein as certain FSA photographers, albeit in service of the Historic American Building Survey (HABS). West Virginian Frances Benjamin Johnston (1865–1952) photographed the French Quarter in the late 1930s and produced an influential series. Some credit Johnston's work for informing the HABS aesthetic, and there are certainly stylistic similarities between her images and some FSA architectural photographs.

Meanwhile, studio photographers carried on their trade, adding another layer to the photographic tradition of Louisiana during those years, with varying degrees of artifice. For example, Indiana-born Joseph Woodson "Pops" Whitesell (1876–1958) rose to prominence for his New Orleans studio portraits, some of them taken in

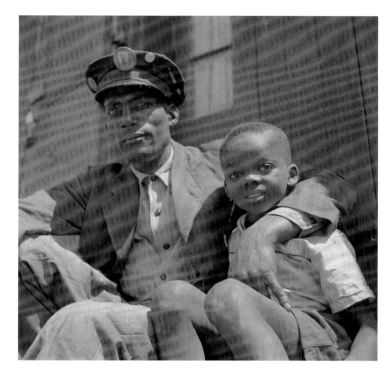

FIG. 14. "New Orleans, Louisiana. Negro dock worker and son." John Vachon, Mar. 1943.

home settings reminiscent of the FSA photographs. Indeed, if we scope back to a regional perspective, we see a group of homegrown studio photographers from small southern towns who began to gain prominence during this period: T. R. Phelps (Virginia), Paul Buchanan and Bayarad Wootten (North Carolina), John Paul Trlica (Texas), and O. N. Pruitt (Mississippi). Other photographers served in black communities, including P. H. Polk (Tuskegee, Alabama), Richard Samuel Roberts (Columbia, South Carolina), and Ernest C. Withers (Memphis, Tennessee). Pruitt photographed paying clients (regardless of race), and his studio blurred the line between commercial and documentary work: he photographed social events for the town, disaster sites for insurance companies, and crime scenes for the police department. In his police-work files, one finds images of an execution by public hanging (1934) as well as a lynching (1935)—the most chilling sort of documentary work (Hudson).

Another Deep South photographer deserves particular mention here, as he was both a contemporary of and a kindred spirit to the FSA cohort. Like them, Theodore Fonville Winans (1911–1992) benefitted from technological advances in photography as he captured

images of south Louisiana. His moving picture, *Cruise of the "Pintail,"* filmed between 1932 and 1933 from land and water using a hand-cranked Kodak camera, records his trip through southern regions of the state from Grand Isle to New Orleans to the Atchafalaya swamp. After attending Louisiana State University, working for the state, and settling in Baton Rouge, Winans opened his studio in 1940, where he focused on portrait photography. Louisiana politicians who sat before his camera include Earl and Russell Long, Jimmie Davis, and Edwin Edwards. While Winans recorded the communities and people of the state around the same time as the FSA photographers, he did so, at least initially, "for fun" (Miller). Until 1938, when he was hired by the state "as a photographer in charge of documenting industry" (Parr), Winans worked without direction, shooting what he wanted while lingering in south Louisiana, creating a rich trove of images that in many cases thematically complement the FSA photographs and that continue to find new viewers even today.

Divergent Photographic Visions

Shahn, Lee, and Wolcott created a number of iconic—and sometimes controversial—images that reflected their individual perceptions as federal employees and artists. Stryker both complimented and critiqued his employees to encourage them to push their personal limits and those of the medium. For example, he wrote of one of Lee's negatives taken in December 1936 near Milford, Iowa, "This was a knock-out of a picture" (Stryker, LSU, reel 1, Dec. 29, 1936). In the same letter, he instructs, "When you take such things as pictures showing dilapidated sides of barns or straw walls, please use your big camera." Less than a month later, he pointed out the need for more varied, natural poses: "You have done many pictures of the families standing in front of their house or shack. They appear a bit stiff taken in this manner" (reel 1, Jan. 1, 1937). Perhaps Stryker's comments early in Lee's career as an FSA photographer influenced his interest in action shots using flash in his later work.

Not all of Stryker's actions were welcome, however. When he initially sorted negatives, he would punch a hole in those he discarded, a practice Shahn called "dictatorial," even claiming, "he ruined quite a number of my pictures" (Shahn interview). In later years, the photographers were given more say in which negatives

to kill, and the killed negatives were left in the files. The Historical Section's manual advises, "If you disagree with Mr. Stryker's notes, or you do not agree that certain prints should be 'killed,' it is your privilege to leave the print in for the files, and so indicate. It is your privilege to kill any prints you do not wish in the files, by tearing the corners" (qtd. in Fleischhauer and Brannan 339).

Though the photographers worked for the FSA, they did not always share the same vision. For example, Lee developed his artistic principles in concert with, and sometimes in opposition to, other FSA photographers. He became convinced that the objective of documentary photography was to capture every detail possible, so he used flash to open up photographed spaces. By contrast, Shahn thought that documentary photography should represent the original setting—even when the space was dim. Dorothea Lange "seldom took her cameras indoors. Evans did, but was usually forced to adopt a posed, formal approach to his interior work or else to leave people out entirely" (Hurley 1978, 17). Meanwhile, Lee, with his "big, harsh flashbulbs, went inside to record the people and the houses they lived in" (17).

Another example of divergent perspectives involves Shahn and a couple of photographs of a shack. In his 1964 interview, Shahn

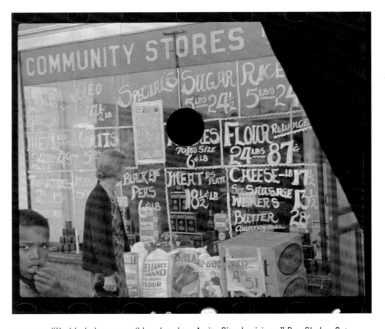

FIG. 15. "Untitled photo, possibly related to: Amite City, Louisiana." Ben Shahn, Oct. 1935. (The punched hole indicates this image was to be discarded.)

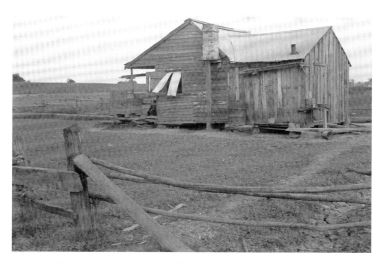

FIG. 16. "Trapper's house, Plaquemines Parish, Louisiana." Ben Shahn, Oct. 1935.

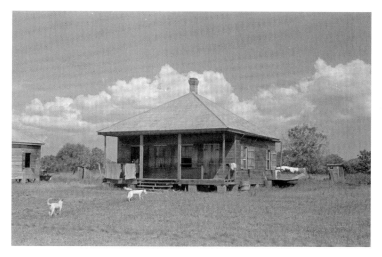

FIG. 17. "Sharecropper's house, Plaquemines Parish, Louisiana." Arthur Rothstein, Sept. 1935.

claimed that he and Arthur Rothstein photographed the same sharecropper's house, though he doesn't specify where. Perhaps the two worked portions of the same beat, but if Shahn documented the same house as Rothstein, those negatives seem not to have survived. In any case, Shahn said that he chose to photograph up close, while Rothstein "photographed [the shack] with a filter," which emphasized the clouds above it and created an image Shahn admits he "didn't care for" (Shahn interview). With the clouds framing Rothstein's picture, Stryker said the shack "looks as if you put two hundred dollars in it you could make a nice little summer home" (Shahn interview). Referring to the FSA/OWI Collection as a whole, Rothstein later claimed that "There was a great deal of honesty in these pictures," regardless of differing photographic perspectives (Rothstein). Two photos of shacks taken by Shahn and Rothstein in Plaquemines Parish demonstrate how these photographers' techniques differed.

The FSA photographs were used for political purposes, and their propagandistic nature cannot be overlooked. In fact, conservative lawmakers frequently accused Stryker and the photographers of disseminating the political line. For his part, Shahn shrugged it off as a true believer in the FSA's mission, stating, "Propaganda is to me a noble word. It means you believe something very strongly and you want other people to believe it; you want to propagate your faith . . . art has always been used to propagate ideas and to persuade" (Greenfeld 114). Shahn readily admitted almost thirty years

after his first trip to the South, "Our function was, if our work was used at all, to convince our congressmen and senators that this is a necessary thing, this Resettlement Administration; and without convincing the public you can't convince a congressman either" (Shahn interview).

Still, Stryker was "a great believer in the integrity of a photograph," according to Rothstein. The FSA employees all shared a social realist outlook, which held that documentary photography was supposed to be truthful. In writing about Wolcott, F. Jack Hurley repeatedly affirms that she expressly intended for her images to educate others about the problems of her time and to inspire those who saw them to act accordingly. Shahn stated in his interview with Doud, "[W]e would avoid all tricks, angle shots were just horrible to us" (Shahn interview). He may have overstated the case, however, since many FSA photographers did use angle shots (consider Wolcott's "Boys fishing in a bayou, Schriever, La.," for example).

More than Shooting Scripts: How Assignments Worked

Looking at the images taken in Louisiana by Shahn, Lee, and Wolcott, one is struck by the scope of their work. The photographers covered agricultural and rural life as well as varied labor practices. A textured portrait of folk traditions also emerges. Lee's experi-

ences in Louisiana made a strong impression on him, and he wrote to Stryker, "If you can possibly make a trip down here I strongly recommend it. You will get a real feeling of the South and its background of French & Spanish domination in this section. And New Orleans is something!" (Stryker, LSU, reel 1, Sept. 13, 1938). In time, Stryker would indeed see Louisiana with his own eyes, when he undertook work for Standard Oil.

When the photographers set off for Louisiana, they had in hand lists of sites and suggestions that Stryker dubbed "shooting scripts." Their destinations included three farmers cooperatives: the Terrebonne Resettlement Project, the Transylvania Project, and the Thomastown Project, which the FSA called Ladelta (Louisiana Delta). The Terrebonne Project, headquartered in Schriever, included 5,705 acres the government had purchased to lease plots to farmers. The cooperative provided its tenants with houses, the first of which was built in 1939 on six acres of land with an outhouse, a poultry house, and a barn (Ellzey).

The cooperatives were designed to provide farmers with the means to work successfully as a group so as to benefit the whole. Accordingly, profits were distributed among members, who were also permitted to sell produce from their private gardens for personal profit. The federal government purchased over 9,000 acres north of Lake Providence in 1937 and the following year developed the Transylvania Project (Adams and Gorton 324). It was an all-white project that included a "meat-curing plant, a canning plant, a cooperative store, and a cooperative selling plan so that the farmers would be able to get the full share of their crops" (Scott 83). African Americans had been living on and farming that land, some of the most fertile in the area, for almost one hundred years. The local FSA administrators in the area "decided our land was too rich for black folks to have," argues John H. Scott in his memoir of the forced resettlement of himself and other African Americans at the time (82). The people did not go quietly, protesting the move, and the black press published stories on the outcry, leading to the NAACP's involvement on both the state and federal levels. The government responded by establishing a second, all-black project at Thomastown, about twenty-five miles south of Transylvania (83), making concessions to guarantee the residents did not end up "under semi-slavery on privately owned farms," as Scott phrases it (93).

While the photographers focused mainly on rural areas, Shahn, Lee, and Wolcott also traveled separately to New Orleans, especially to cover efforts of the U.S. Public Health Service. The Health Service existed before the New Deal era, but additional grants were given to states during those years for sanitation, education, and outreach. The WPA and the Public Works Administration (PWA) built grant-funded health centers, including Charity Hospital (1939) on Tulane Avenue in New Orleans.

Once the photographers arrived in Louisiana, a wider network of native contacts sometimes facilitated their work there. Stryker specifically named Dr. Slaughter at the Marine Hospital on State Street and Dr. F. A. Troie, who was in charge of the Quarantine Station, as liaisons for Wolcott during her stay in New Orleans (Stryker, LSU, reel 2, May, 25 1939). In several letters, Wolcott mentions George Wolf, an RA and later FSA Regional Information Advisor. Wolf steered her toward cooperative farming projects, writing to Stryker on January 5, 1940, that the Terrebonne Project "is in good shape for photographing, and will make good pictures at any time" (Stryker, Smithsonian, no. 24). Wolf also wrote to Stryker, "Transylvania and Ladelta will have their community buildings completed in another month" (no. 24). Wolcott's visit to all three cooperatives in the summer of 1940 was timed to show them at their most presentable.

Both Lee and Wolcott noted Lyle Saxon's influence regarding Melrose Plantation in Natchitoches Parish. In a September 13, 1938, letter to Stryker, Lee wrote, "[W]ill go up to Saxon's farm at Melrose for a few days and get some pictures of a more or less isolated mulatto colony along Cain [sic] River" (Stryker, LSU, reel 1). And Wolcott wrote almost two years later, in July 1940, "I also saw Lyle Saxon, talked to him, & mentioned I was going to Natchitoches. It is right in the center of the territory where he got his material for 'Children of Strangers'—the free mulatto section" (reel 2). Saxon's 1937 novel, *Children of Strangers,* concerns the lives of the Cane River's Creoles of color and the fate of a "tragic" mulatto rejected by groups on both sides of the color line—a common literary motif of the time. Indeed, Wolcott followed Saxon's suggestion, visiting and photographing the community.

Local resettlement directors sometimes put photographers in touch with their human subjects and later furnished case histories of those who had been documented. We uncovered the identity of two individuals Shahn photographed in Tangipahoa Parish—Mary Fontana (Independence) and James Temple (Amite)—because E. G. Kemp, the agent for the Louisiana Rural Rehabilitation Corporation, mailed Shahn their case files, which remain among Shahn's papers. (The case file for a third person, Steve Doty [Amite], was

also sent to Shahn, but we could not locate him among Shahn's portraits because none are tagged with Doty's name.) These files offer an opportunity to know something more about the poor who were photographed for the FSA but to our knowledge have never before been linked to their backstories. (See the appendix for the text of the case files mentioned here). Temple's file bears the notation "(col)" for "colored," and states that he has "developed a bad case of rheumatism caused, supposedly, from drinking poisonous whiskey." Shahn seems to have mislabeled the Fontana family as the Fortuna family—and so they remain under that name in the FSA records. This is cruelly ironic, given that "fortuna" can mean, variously, "luck," "success," and "fortune" in Italian, and theirs was a particularly unfortunate family. The father passed away from cerebral cancer shortly after they emigrated from Italy, leaving the mother and eight children to deal with the successive catastrophes of crop failure, the death of their mule, a subsequently mortgaged farm, and malaria. Evidence of their native Italian culture appears in the photos Shahn took: the place of pride for their Madonna tapestry and a wood-burning oven (*forno in terra cruda*) in their yard, clearly a design from the Old Country recognizable to travelers to southern Italy (see Plates 17 and 18 in the gallery). Discussing the photo of the "Fortuna" daughter in front of the Madonna tapestry, a photograph of which he was proud, Shahn said, "There is a little girl, sort of very meager looking, tragic eyes, and she was walking through the hallway of her home and there was a huge reproduction of Raphael's Holy Mother" (Shahn interview). One of the photos of the family that Stryker rejected, ostensibly on the basis of a blurred face, might depict the mother and her seventeen-year-old daughter described in the case file (see Plate 19 in the gallery). The rest of their story remains to be told by the living descendants of the "Fortuna" family.

Letters of introduction to project managers could sometimes backfire, however, and hasten a quick change of plans. For example, the Arkansas RA regional director—a plantation owner—purportedly said to Shahn, "What the hell are you coming down here for, making more trouble for us?" (Greenfeld 125). While in that state, Shahn had been assigned to meet with Arkansas Senator Joseph Robinson, whose antilabor stance likely made associating with an FSA photographer more of a liability than an asset. After an uneasy couple of days with the senator, Shahn left for the Louisiana delta with deliberate haste, demonstrating the photographers' need to be flexible.

Though Stryker gave the photographers specific cities and towns to shoot, along with the FSA programs in each locale, he did not always author the scripts. "The variety of scripts found in the written records suggest that Stryker often encouraged others to develop the scripts" ("Farm Security Administration/Office of War Information Written Records: Selected Documents"). For his part, Stryker was at best vague about what constituted a shooting script in a 1972 interview ("Roy Stryker on FSA" 7, 11). He recalled that they were "very diverse. I made a remark to one guy, 'You know, people sit on their front porches.' My mind immediately began to run—We don't want a thousand pictures of people sitting on their front porches. I was busy trying to think how I could get a few of those and get good ones" (11). In his plainspoken way he commented, "I'd like to have found a family where we could've put a photographer in there like Marion Post, who had a wonderful feeling for families, and let her go with that family. Let her stay around for three or four days and go to church with them. But I thought to myself, 'Roy, if you don't watch out, you'll be shooting the whole goddamn United States, down to going out to the toilet with them'" (11).

Sometimes Stryker sent memos informing the photographers of images needed for the collection. One from 1937 with the subject line "Suggestions to be used in preparing a shooting script for a picture story of the Mississippi" includes the instruction "Assemble as much historic material as possible" and lists major river towns from Minneapolis to New Orleans (Stryker, Smithsonian, no. 24). It also directs the photographers to pay special attention to the "The River front" since it "has its own special characteristics (people; architecture)" (no. 24). Some memos specified activities and people to photograph rather than locations. For example, an undated memo sent "To All Photographers" with the subject "Pictures Needed for Files" simply lists "Crowds—lots of people with faces showing—young people in evidence," "Baseball," and "Pictures of special festivals and contests, e. g. potatoe [*sic*] harvest festival, wood-chopping, log-rolling, corn-husking, etc." (no. 24).

Stryker also directed the photographers to take additional images of small-town life, including post offices, general stores, and churches. They responded with pictures of local residents in front of buildings or images of the buildings themselves. He tried to keep them mindful of standards for captions as well; among the handful of letters from him in Shahn's papers is one with a gentle reminder: "Some day you are going to have to add additional information: 'Central Ohio' is a little vague" (Aug. 2, 1940).

Photographers frequently went off script in response to weather conditions or local events discovered only after reaching an area, but Stryker insisted that they do more than go on a junket: "[Y]ou had to be careful not to get them going until they went through every town and just shot the thing on their way through the town" ("Roy Stryker on FSA" 11). Shahn's affiliation with the Special Skills Division, not the Historical Section, meant that there was no precise itinerary as he set out for his southern circuit in a Model A Ford with Bernarda Bryson, the woman who would become his second wife.

Stryker's interests extended beyond the obligatory documentation of federal projects and outreach efforts. He and his photographers were always eager to find additional opportunities "to continue the work of documenting American life, even during periods when there was little or no money in the budget for 'frills' such as recording the American scene" (Hurley 1972, 108). Photographers' letters to Stryker from the field attest to their diversions from the scripts when opportunities arose. Shahn, Lee, and Wolcott used their cameras to capture both the familiar and obscure, from a lounge at land's end in Pilottown—the historic structure stood until it was effaced by Hurricane Katrina—to sharecroppers' spartan quarters to the streets of New Orleans.

Agendas were subject to revisions, as Lee demonstrated in 1938. Answering the general call for more photos of festivals and contests, he was keen to stay in Louisiana through the Crowley Rice Festival that year. He wrote to Stryker on September 16 explaining his plan to photograph the festival and "also cover the State Fair for the southeastern section at Donaldsonville," along with All Saints' Day activities in New Roads (Stryker, LSU, reel 1). Today, visual records of all three exist because of Lee's decision. Wolcott, on the other hand, mentioned in letters to Stryker how little time she had for any creative digression from itineraries. Her FSA assignments often positioned her as a sweeper, completing others' unfinished projects, ranging from Lake Providence down to New Orleans. In an undated letter sent during the summer of 1940, she specifically names Lee and then comments, "Is he as good at missing projects as Lange was?" (reel 2).

Ethnic and Racial Identities

Along with taking pictures, the photographers were responsible for writing captions, which sometimes occasioned misspellings of locations and names, such as Shahn's Fortuna/Fontana mistake. The captions also recorded ethnic and racial assumptions of the time. For example, African Americans were more often referred to by race, while whites were identified by their ethnicity, name, or job (Dablow 12). Shahn, Lee, and Wolcott tended to keep the captions brief, but they did add further explanation when deemed necessary for their general American audience. For instance, in one caption Lee not only describes what a *fais do-do* is but also addresses the Cajuns' "French origin" and "clannish" nature, noting that dances "are usually attended by family groups" ("FSA-OWI Photographic Prints"). He points out the rice straw mattresses where children slept while their parents continued to dance and socialize. It is fitting that Lee included this detail since *fais do-do* is French for "go to sleep," a command mothers would give their little ones who had attended the dances with their parents. Other Louisiana ethnicities—the Creoles of Plaquemines Parish, the Italians of the Fortuna/Fontana family, and the Spanish residents of St. Bernard

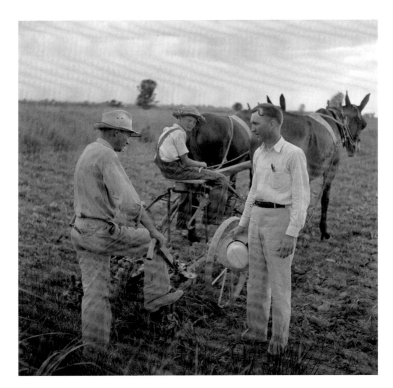

FIG. 18. "Farm Supervisor talking to one of the project farmers. Transylvania, Louisiana." Marion Post Wolcott, June 1940.

Parish—are similarly included in Shahn's, Lee's, and Wolcott's labels, reflecting the state's diverse populace.

One of Lee's 1938 Donaldsonville State Fair photos reveals his simplification of Native American identity. By labeling a glass-eater as an "Indian" performing at the fair, Lee missed the distinctions of Chitimacha, Coushatta, Jena Band of Choctaw, Tunica-Biloxi, and Houma, none of whom are specified in his negatives taken in Louisiana (see Plate 110 in the gallery). The photo is an interesting bit of Americana and yet exposes nothing about the realities of Indian life in the state. However, Native knowledge does show up unbeknownst to Lee in one image: his "Detail of construction on hundred-year-old mud and moss chimney of farmhome of aged Cajun couple living near Crowley, Louisiana" (see Plate 91 in the gallery). It illustrates the Cajun approach to wattle-and-daub construction, called *bousillage,* which some believe the Cajuns learned from Native Americans. The use of Spanish moss as a binder was an important building technique in a time and place when bricks could not be had. In Louisiana culture, the origins of things are often traceable to a mix of cultural and ethnic influences.

Similarly, Louisiana racial politics of the 1930s could not be reduced to the simplistic white-black binary that dominated national discussions; FSA photo captions consequently reflected a variety of racially coded labels, such as "Creole," "mulatto," and "colored," along with "Negro." By further identifying an unemployed Creole trapper with "Negro" in parentheses following the main caption, Shahn signaled he meant a Creole of color, reflecting shifting notions of the term "Creole" that might not have been well understood beyond Louisiana (see Plate 11 and caption in the gallery). In contrast, Lee and Wolcott did not use "Creole" as a signifier of either race or ethnicity. They did, however, use "mulatto," especially when describing the men, women, and children who lived along the Cane River in the area of Melrose. Regarding one such man she photographed, Wolcott commented years later he did not "seem nearly as repressed or silent as so many Louisiana black people do" (qtd. in Hendrickson 166; see Plate 129 in the gallery). Her remark reveals something of an ingenue's perspective on the complicated racial hierarchies of the region. As Gary B. Mills explains in *The Forgotten People: Cane River's Creoles of Color,* "These people have consistently refused to identify themselves as Negro, and the term *mulatto* is particularly detested" (xix).

The FSA/OWI Collection also records the reality of state-sponsored segregation as outlined in the separate but equal doctrine. In a June 19, 1940, letter to Stryker, Wolcott writes, "In Louisiana I did Transylvania (the white project) inside out—and quite a few on Ladelta, the negro project altho the rain prevented me from doing as complete a job there" (Stryker, LSU, reel 2). Wolcott captured a farm supervisor in the field with one of the farmers, both white men. A year earlier, Lee photographed an African American woman teaching her children in a place they were soon forced to leave. Jane Adams and D. Gorton discuss the realities of segregation and the FSA cooperatives in "This Land Ain't My Land: The Eviction of Sharecroppers by the Farm Security Administration." In their article, they study Lee's photographs taken at Transylvania in January 1939, at which time "the evicted tenants were packing up and the new white clients were arriving" (Adams and Gorton 331). According to them, "Transylvania Plantation, East Carroll Parish, Louisiana, remains the best documented, and perhaps the most egregious, instance of the eviction of a long-established African-American community and its replacement by white clients" (Adams and Gorton 329). While Lee's captions explain that the African American people he photographed in January 1939 would be resettled, they do not specify that the local FSA administrators demanded that they leave Transylvania; the images themselves embody segregation as it existed within the federal programs. In September 1938, only four months before taking photographs at Transylvania, Lee took a series of photos of people in Raceland enjoying a crab boil—an all-white crowd gathered around the table topped with crabs and Jax beer bottles. Their black counterparts did the same no doubt but in a separate place.

Dean Dablow points out what is missing in the racial lexicon of the FSA collection: the "Ku Klux Klan, cross burnings, lynchings, or other overtly negative signs. This visually unracist presentation stems from Stryker's wanting to show all Americans in a dignified manner. Racial inequality was not an issue which Stryker wanted to pursue" (Dablow 12). Even so, sometimes sentiments of injustice were very much evident, as in Lee's caption for a photograph of a couple of African Americans returning from hunting: "Negro laborers employed by Joseph La Blanc [*sic*], wealthy Cajun farmer, Crowley, Louisiana, with possum and birds they shot." Meanwhile, Lee's portrait of "La Blanc"—posed and unsullied in his riding pants and spurs, clutching his brace of fowl—radiates his status. Similarly, one of Dorothea Lange's photos shows the monument at Liberty Place in New Orleans, which commemorates the White League's seditious and largely successful campaign to resist Recon-

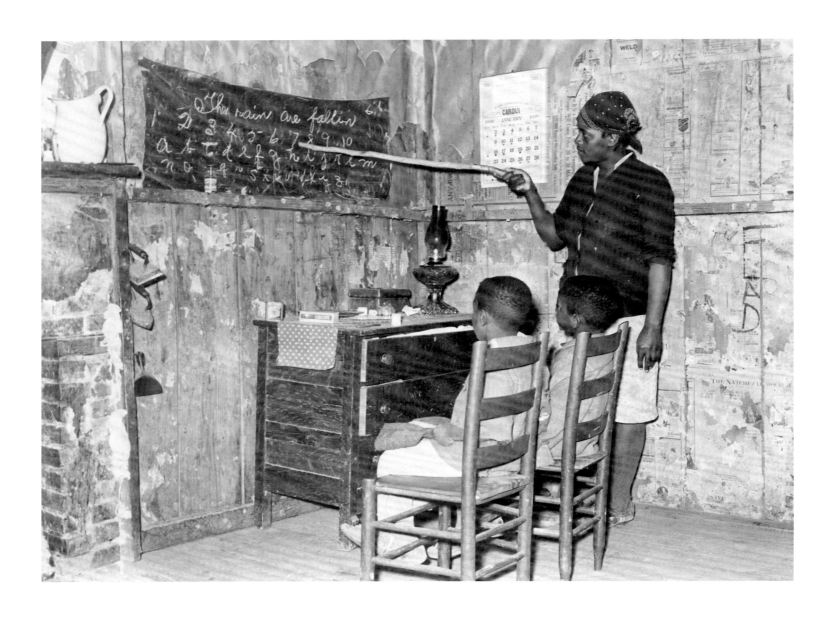

FIG. 19. "Negro mother teaching children numbers and alphabet in home of sharecropper. Transylvania, Louisiana." Russell Lee, Jan. 1939.

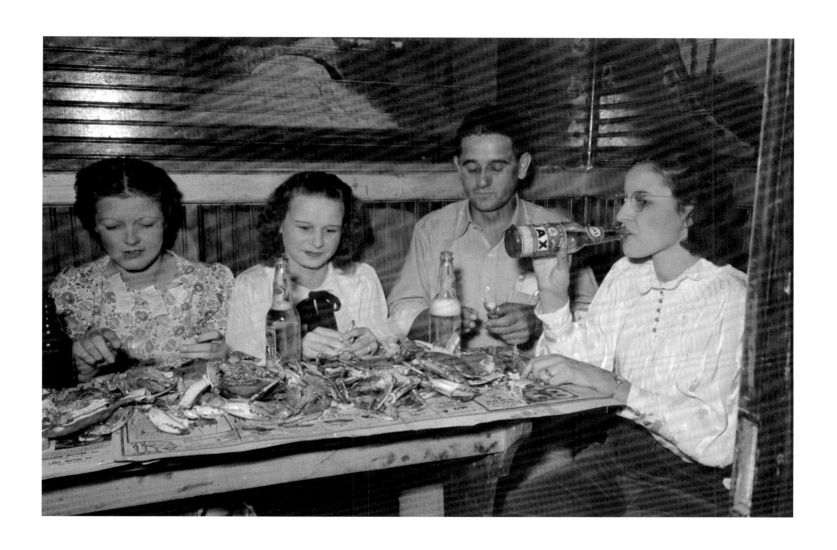

FIG. 20. "Crab boil, Raceland, Louisiana." Russell Lee, Sept. 1938.

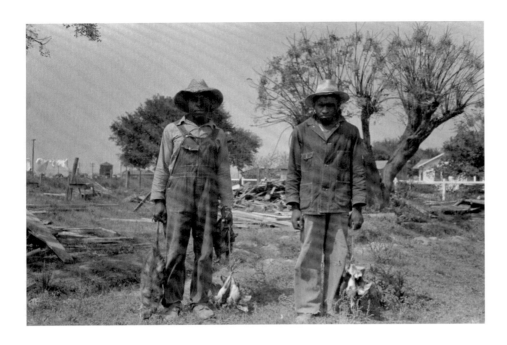

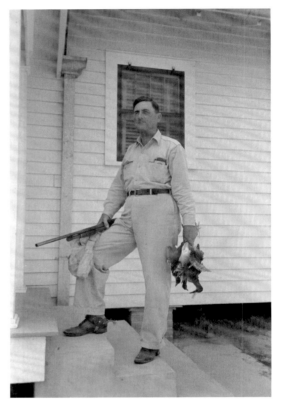

FIG. 21. "Negro laborers employed by Joseph La Blanc, wealthy Cajun farmer, Crowley, Louisiana, with possum and birds they shot." Russell Lee, Nov. 1938 (*left*).

FIG. 22. "Joseph La Blanc, wealthy Cajun farmer, standing on steps of home with birds from a morning shooting, Crowley, Louisiana." Russell Lee, Nov. 1938 (*right*).

FIG. 23. "One side of the monument erected to race prejudice. New Orleans, Louisiana." Dorothea Lange, July 1936 (*bottom*).

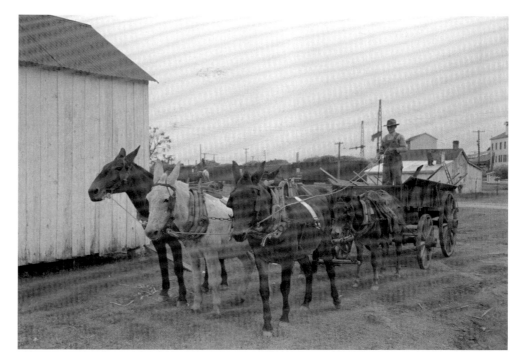

FIG. 24. "Fly wheels and speedometer cables in junk-yard, Abbeville, Louisiana." Russell Lee, Nov. 1938.

FIG. 25. "Mules and wagon, Port Barre, Louisiana." Russell Lee, Oct. 1938.

struction government and to disenfranchise blacks. Lange photo-graphed the monument just a few years after an inscription affirm-ing white supremacy had been added, and she wrote this simple, clear-sighted, and unflinching caption: "One side of the monument erected to race prejudice."

Double-Edged Progress

Mechanization in Louisiana was still developing in the 1930s, but one of its primary embodiments, the automobile, had become a familiar presence. Junkyards brimming with discarded motor parts were the subject of a series of photographs Lee made in Abbeville. Not far from there, he photographed the still-used agricultural equipment of mules and wagons. They would persist in parts of the rural South for years, even though mechanization of farming was the region's future (Conkin and Field 45).

In an October 26, 1938, letter to Stryker, Lee writes, "Am getting pictures of sugar cane now. The industry is highly mechanized and will be more so in a year or two. There is a new sugarcane harvester that I will get pictures of around New Roads, La" (Stryker, LSU, reel 1). The Caption accompanying his photo of the machine also ad-dresses the operational issues involved: "Wurtele sugarcane har-vester bogged down and out of temporary running condition, Mix, Louisiana." Earlier that month, he photographed a man and boy working in a similar sugarcane field, proving the continued need for manual labor. Lee did not record either the race or the ethnicity of these workers, but it is clear from the image that they are African American. With the coming of the tractor, sugarcane farmers began laying off their African American workforce, a situation that stirred racial tensions. The fiction of Louisiana author Ernest Gaines de-picts the migration of younger African Americans away from the South and farming as tractors displaced older men in the fields during the early 1940s in novels such as *Catherine Carmier* (1964) and *A Gathering of Old Men* (1983). The automobile, along with other modes of faster transportation, allowed those on the lower rungs of the social ladder to search for opportunities elsewhere.

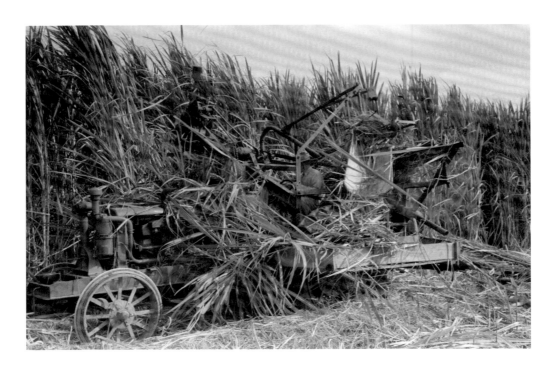

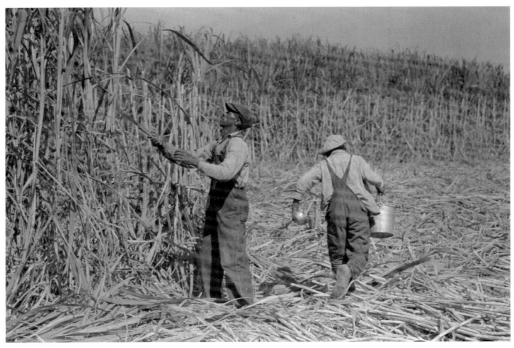

FIG. 26. "Mechanical sugarcane harvester developed by Allen Ramsey Wurtele, Mix, Louisiana. Mr. Wurtel spent several years with this development, and the machine is semi-successful. It is recognized that with developments and improvements pending, this machine will be in successful operation within a few years." Russell Lee, Nov. 1938.

FIG. 27. "Sugarcane cutter and waterboy in field near New Iberia, Louisiana." Russell Lee, Oct. 1938.

Gaines also writes about competition in Louisiana for the best land to work, often pitting Cajuns against African Americans in a system perpetuated by wealthy landowners.

Shahn, Lee, and Wolcott documented what historian Shane Bernard sees as a watershed moment in a period of transition in Louisiana, a point historian Roger Biles emphasizes as well in terms of the South at large. Following World War II, the region became more homogenous with the overall American culture, but "the first crucial steps in new directions came in the 1930s" ushered in by the New Deal (Biles 154–55). Less than a decade later, Lafayette Parish farmers "had almost universally adopted mechanization" (Bernard 39). The itinerant movement encouraged by federal programs and pursued by Stryker's photographers all over the nation aided the chipping away of state borders and cultural boundaries.

In his book *Home Town* (1940) writer Sherwood Anderson used FSA photographs, three of which were taken by Lee and two by Shahn, to illustrate the point—as he put it in his March 28, 1940, letter to Stryker—that "radio and the movies have changed life in the towns. It has pretty much broken up the little assembly of citizens" (Stryker, LSU, reel 2). Ironically, the FSA images, reminders of the country's idiosyncrasies before radio, movies, and schools produced a more uniform American culture, were instrumental in generating popular notions of a unified nation in the decades that followed. In her introduction to *FSA: The American Vision,* Beverly W. Brannan argues that the photographs were "an important means through which the nation came to comprehend its own vastness and diversity" (Mora and Brannan 20). They exposed little-known sections of the United States—the Deep South and Louisiana in particular—to the rest of the nation and made them more familiar, consequently preparing the way for assimilation in the coming years.

Legacy

The story of the FSA collection continued well after the photographers moved onto other endeavors. In September 1943, Stryker was battling Congress to defend the integrity of the whole collection from a push to separate the earlier FSA negatives from the OWI batch, which were produced to encourage support for the war. Stryker successfully argued against that move, writing, "such dis-

memberment would be fatal, for this is a live, an active recording" (Stryker, Smithsonian, no. 8). In his effort to keep the collection undivided, Stryker requested help from the White House since, as he told Dorothea Lange at the time, "The whole trend in this town [Washington, DC] is now against the things which we were doing" (no. 8). He wrote to Jonathan Daniels, the administrative assistant to President Roosevelt, maintaining that it was "possible to preserve the record intact and still make it available to the OWI and the other War Agencies for current use" (no. 8). He purposefully repeated to Daniels his belief that the images taken before the war and those during the war years were intertwined, and he specifically named the Library of Congress as an appropriate depository (no. 8). The hard-won victory was accomplished by September 16, 1943, when Stryker wrote Lange to announce his retirement, a decision he made only after the government agreed to transfer the entire collection to the Library of Congress. Of this transfer, he wrote, "The file, I feel certain is safe and will go into proper hands. Some very strategic people are now supporting it" (no. 8).

Stryker had hired archivist Paul Vanderbilt in 1942 specifically to organize the prints. When the photographic collection was moved to the Library of Congress, Vanderbilt implemented a lot system he created for the negatives. In fact, he followed "the collection to the library, where he soon became the chief of the institution's new Prints and Photographs Division" (Fleischhauer and Brannan 331). There, he "microfilmed 1,800 of the [2,200 total] lots," the equivalent of 88,000 of the approximately 176,000 negatives available on the Library of Congress site today (332). Not all of the negatives were assigned specific lot numbers, which usually referred to the region and subject matter of the image. Vanderbilt intended for the lots to reflect "photo stories," and some images were not easily fitted into storylines imposed years after many of the photos were taken ("FSA-OWI Photographic Prints").

Stryker went on to work for the Standard Oil Company from 1943 until 1950, during which time he collected images of the global industry, tracing oil from discovery to the marketplace. The project amassed some half-million photographs and was hailed as one of the finest and most extensive documentary projects of its time. Under Stryker's tenure a pivotal moment in the company's propaganda efforts—and indeed, American film history—occurred with Robert Flaherty's high-production value film *Louisiana Story* (1948). Asked about his attraction to working for a corporation after public service, Stryker responded, "Well, I thought Standard Oil

was an exciting thing; running oil. They gave me a quick trip down. I saw those drillers—fascinating people, a fascinating spot. I saw the oil coming up, down in the bayous down in Louisiana" ("Roy Stryker on FSA" 15).

Of the three photographers, only Lee continued to pursue the craft professionally. He worked under Stryker during his years with the FSA-OWI and afterward at Standard Oil, before he moved to Austin, Texas, in 1947. Shahn had intended photography to be only a tool for creating studies for his works in other media. If he ever flirted with becoming a photographer in his early enthusiasm, he ultimately gravitated back toward painting following his FSA-OWI employment. Shahn and Lee both concluded their careers in academia, with Shahn joining the Harvard faculty in 1956 and Lee becoming the first instructor in photography at the University of Texas in 1965. As for Wolcott, she met Lee Wolcott in 1941, married him, and soon after left the Historical Section to raise a family. She never returned to professional photography, though her work made its mark in the classroom, too. Howard Odum, a sociologist often credited with bringing the New Deal to the American South through his research as a professor at the University of North Carolina, maintained an extensive photo file of work by Wolcott. He used those photographs extensively in his classes and exhibits documenting conditions in a region that was seen as struggling to modernize. Odum was a friend of Stryker, who, in the summer of 1939, dispatched Dorothea Lange to Chapel Hill to assist in Odum's research and to photograph some of the women Margaret Jarman Hagood had interviewed for her book *Mothers of the South: Portrait of the White Tenant Farm Woman* (1939). In October 1939, Wolcott followed suit and continued photographing in the environs of Chapel Hill, documenting the lives of southern women and leaving Odum a rich photo archive for his classes—classes noted for sending a generation of southern activists into the field to address social problems (Daniel).

Through the decades and up to the present, exhibits and publications across the nation attest to the continuing importance of the FSA/OWI Collection. From March through April 1955, the Brooklyn Museum ran an exhibition of social-commentary photographs throughout history. Along with images of Civil War battle sites taken by Matthew Brady, the slums of New York captured by Jacob Riis, and Lewis Hine's photographs taken for the National Labor Committee, the curators selected photographs from the FSA collection. The show included images by all the photographers who worked for the administration, thereby conferring to each a place in the history of photography. In 1991, photographer Dean Dablow set out to retrace FSA photographers' steps in Louisiana, "seeking the sites photographed" decades earlier (Dablow 1). His endeavors led to a "framed exhibit that toured the state" and subsequently to the publication, in 2001, of *The rain are fallin': A Search for the People and Places Photographed by the Farm Security Administration in Louisiana, 1935–1943* (1). Farther west, Bill Ganzel undertook a similar project that resulted in *Dust Bowl Descent,* published in 1984. The book includes a 1979 portrait of Florence Thompson and her daughters, known from Dorothea Lange's celebrated "Migrant mother" photograph. In 2014 a team at Yale University created Photogrammar, a Web-based platform that facilitates access to approximately 170,000 of the photographs taken by the FSA-OWI. Created to disseminate the images more widely to contemporary viewers, Photogrammar is aptly named, for this massive government photo-documentary collection has come to form an American visual idiom.

Southern Exposure

Archivists estimate that there have been more photographs taken in the past decade than in all years prior. Mobile-phone cameras have made everyone a documentarian, and so it is easy to forget that photography was once a less prevalent activity and to take the availability of images today for granted. The FSA photos served a critical educational purpose in their time. The photographers' evident passion and commitment, though expressed through sometimes divergent artistic techniques, were the driving forces behind a remarkable convergence that offered not just a view, but a revelation, of the nation.

Images of Depression-Era Louisiana: The FSA Photographs of Ben Shahn, Russell Lee, and Marion Post Wolcott presents a carefully curated cross section of the FSA Louisiana photographs that rewards with new insights into the state's history. Each image reveals something specific about the cultural and economic realities of a locale's past. The photos reflect mostly rural communities that were practically unexposed to the larger world until FSA photographers arrived. Louisianians working in sugarcane, strawberry, and rice fields. Barefoot children fishing in lakes and looking for crawfish

along the bayou. Urban scenes are captured too: people sharing a bench in the French Quarter, "scabs" shipped into the city because of labor disputes.

The 147 pictures selected for the gallery reveal the power of an image to speak across time. Subject matter, thematic and aesthetic content, and balanced representation of places and photographers comprised criteria for inclusion. Grouped by photographer and then organized by parish, the photos appear in general chronological order, though exact sequence is not known in some instances. For example, Lee took photos in some parishes, left, and then returned later for more.

The captions are reproduced here as they appear in the Library of Congress records, including misspellings. Writing the captions fell to the photographers, but they did not include one with every photo they took. The phrase "Untitled photo, possibly related to [etc]" was added later. The "Untitled" designation was also given to unprinted images at the time the collection was organized and catalogued ("About the FSA/OWI Black-and-White Negatives").

It has been said that many authors write about a time just before their own, a time that is just out of reach and therefore holds a peculiar fascination. Perhaps that is the final appeal of the FSA Louisiana photographs. Gone are the wireframe glasses, the homespun, the mules. And yet we've heard the Depression stories, and austerity is no stranger to our own age. We read the faces captured in these photographs for their personal histories and feel that they are among us still; indeed, we glimpse vestiges among their descendants. Shahn's, Lee's, and Wolcott's photographs remind us that displacement, migration, unsettling, and resettling continue to shape the Louisiana story we live, celebrate, and study today.

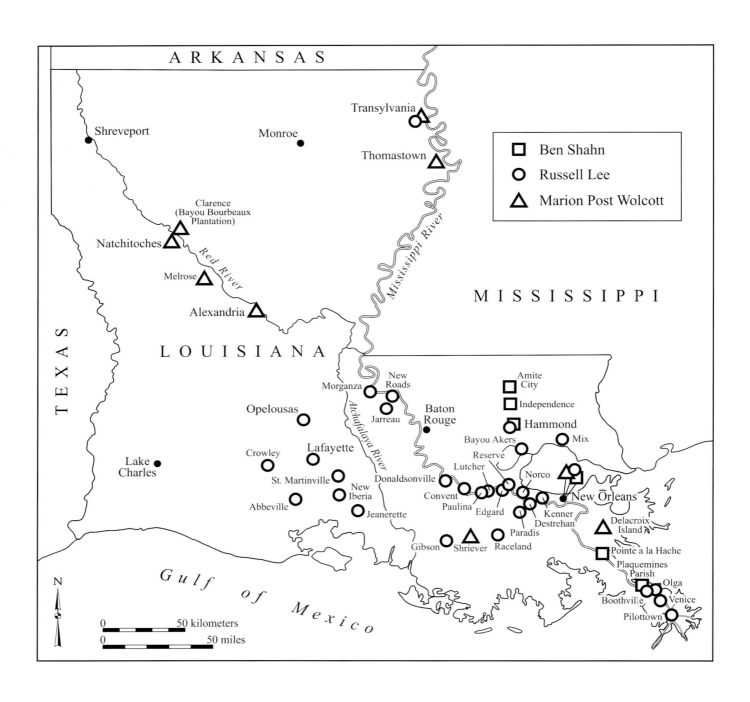

ARKANSAS

Transylvania

Shreveport

Monroe

Thomastown

MISSISSIPPI

Clarence
(Bayou Bourbeaux
Plantation)

Natchitoches

Melrose

Red River

Mississippi River

Alexandria

LOUISIANA

New
Roads

Amite
City

Ben Shahn

Russell Lee

Marion Post Wolcott

Independence

Morganza

Hammond

Atchafalaya River

Baton
Rouge

Bayou Akers

Mix

Opelousas

Jarreau

Reserve

Lutcher

Norco

Crowley

Lafayette

Donaldsonville

Convent

Paulina

Edgard

Kenner

New Orleans

Lake
Charles

St. Martinville

New
Iberia

Abbeville

Destrehan

Delacroix
Island

Jeanerette

Paradis

Pointe a la Hache

Gibson

Shriever

Raceland

Plaquemines
Parish

Olga

Boothville

Venice

Pilottown

N

Gulf *o* *f* *M* *e* *x* *i* *c* *o*

TEXAS

0 50 kilometers

0 50 miles

THE PHOTOGRAPHERS' ITINERARIES IN LOUISIANA

IT IS POSSIBLE TO RECREATE the basic itineraries of the photographers through their letters to Stryker, their photo captions, and government documents. Shahn, for example, apparently wasted no time in getting to work. He received his appointment letter on September 16, 1935, and his first day of work was on September 19. Furnished with his list of RA contacts on September 23, by October he was crossing the country, photographing in Pennsylvania, West Virginia, Kentucky, Tennessee, Arkansas, Mississippi, and Louisiana. The paper trail documenting his movements includes a telegram dispatching him to a difficult meeting with Senator Robinson in Little Rock (Oct. 7), as well as his hotel bill there (Oct. 10–17) (Shahn Papers). His Mississippi images were captured around Natchez with a presumed brief stop in Woodville, not far from the Louisiana state line. Biographer Howard Greenfeld notes that Shahn returned to Washington, DC, on November 8, 1935, and deposited thirty-two rolls of 35-millimeter film and nine rolls of 16-millimeter movie film. Triangulating these known facts, it's possible to surmise that Shahn most likely carried out his work in Louisiana over the course of roughly two weeks, from approximately October 20 until (at latest) early November. Lee's and Wolcott's travels can likewise be mapped through their correspondence with Stryker, among them date-stamped letters from the Hotel Monteleone in New Orleans and the Azalea Court in Lafayette.

BEN SHAHN
Amite City; October 1935
Hammond, strawberry farms; October 1935
New Orleans, Public Health Project; October 1935
Point a la Hache; October 1935
Plaquemines Parish; October 1935

RUSSELL LEE
New Orleans, Public Health Project; September 10, 1938
Trip to the Gulf of Mexico (by boat and return by car), Mississippi River Project; approximately September 15–20, 1938
New Orleans, Public Health Project; September 20, 1938
Crowley, Crowley Rice Festival; October 1–4, 1938
New Iberia, new sugarcane harvester; October 26, 1938
New Roads, All Saints' Day; October 31–November 1, 1938
Lafayette; November 23 or 30, 1938 (based on a letter with only "Wednesday," the month and year provided, and written in late November)
Lake Providence, Transylvania Project; November 8, 1938
Lake Providence, Transylvania Project (again); January, 18 1939
Hammond, strawberry farms; April 5–8, 1939

MARION POST WOLCOTT
Lake Providence, Transylvania and La Delta Projects; June 1–4, 1940
New Orleans, Public Health Project; June 21–25, 1940
Schriever, Terrebonne Project; between June 25 and July 18, 1940
Melrose and Natchitoches, John Henry Plantation; between June 25 and July 18, 1940
Alexandria, Camp Claiborne; December 18, 1940
New Orleans, Public Health Project; January 5, 1941

THE FSA PHOTOGRAPHS OF BEN SHAHN / RUSSELL LEE / MARION POST WOLCOTT

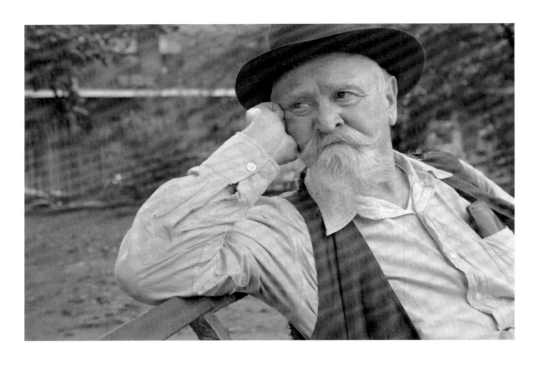

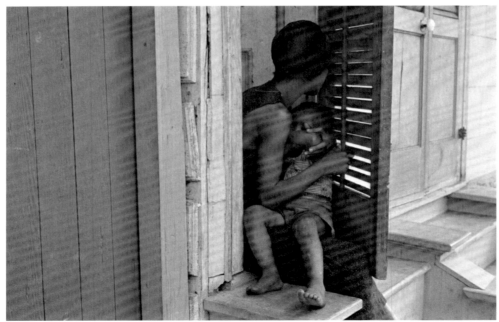

PLATE 1. "An old sailor snapped in Jackson Square, New Orleans." Ben Shahn, Oct. 1935.

PLATE 2. "Scene in New Orleans, Louisiana." Ben Shahn, Oct. 1935.

PLATE 3. "Scene in New Orleans, Louisiana. A street tailor." Ben Shahn, Oct. 1935.

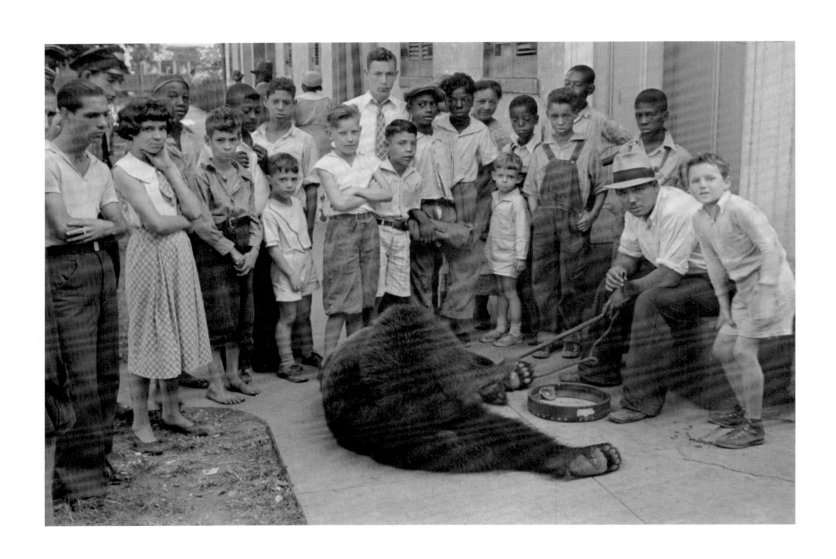

PLATE 4. "Street scene, New Orleans, Louisiana." Ben Shahn, Oct. 1935.

PLATE 5. "Bringing in scabs, New Orleans, Louisiana." Ben Shahn, Oct. 1935.

PLATE 6. "Scene in Jackson Square, New Orleans, Louisiana." Ben Shahn, Oct. 1935.

PLATE 7. "Keeper of a mission flophouse, New Orleans, Louisiana." Ben Shahn, Oct. 1935.

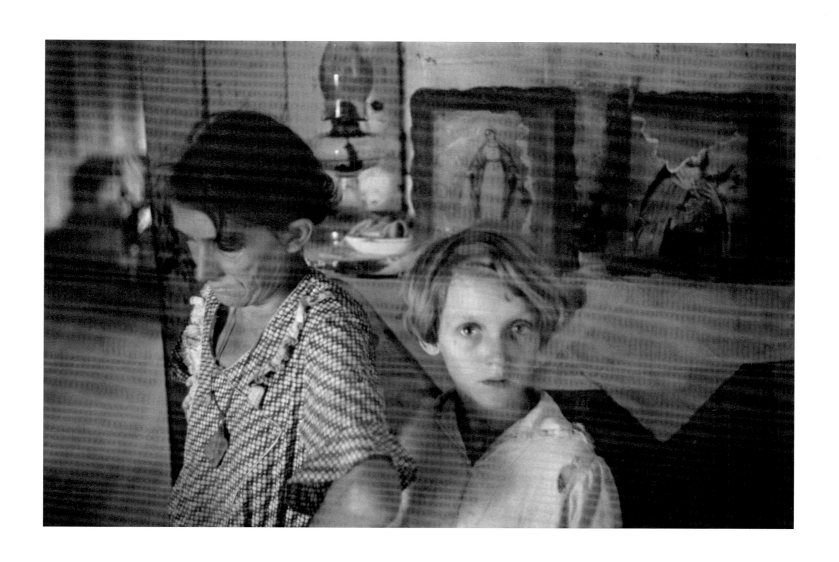

PLATE 8. "Untitled photo, possibly related to: Trische family, tenant farmers, Plaquemines Parish, Louisiana." Ben Shahn, Oct. 1935.

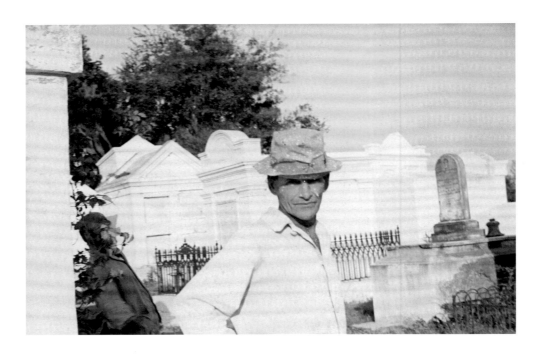

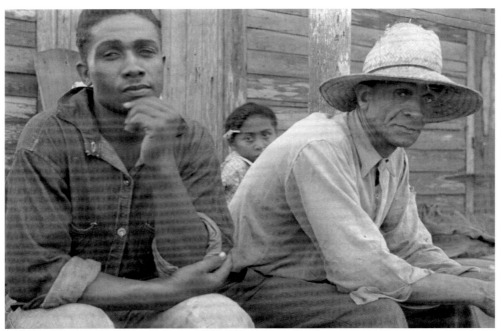

PLATE 9. "Tomb painter in cemetery at Pointe a la Hache, Louisiana." Ben Shahn, Oct. 1935.

PLATE 10. "Untitled photo, possibly related to: Unemployed trappers, Louisiana." Ben Shahn, Oct. 1935.

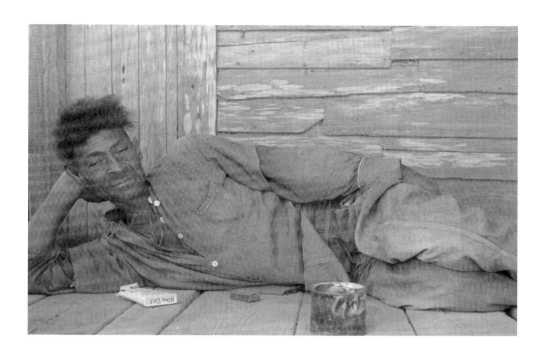

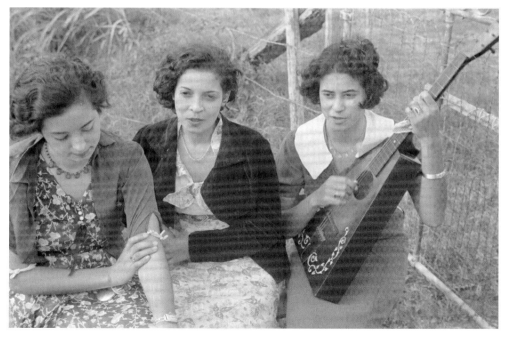

PLATE 11. "Florestine Carson, unemployed Creole (Negro) trapper, Plaquemines Parish, Louisiana." Ben Shahn, Oct. 1935.

PLATE 12. "Creole girls, Plaquemines Parish, Louisiana." Ben Shahn, Oct. 1935.

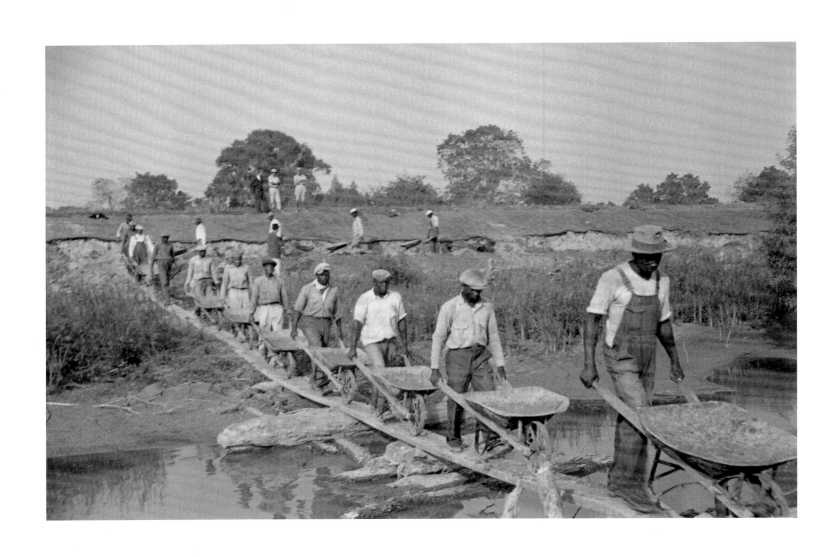

PLATE 13. "Levee workers, Plaquemines Parish, Louisiana." Ben Shahn, Oct. 1935.

40

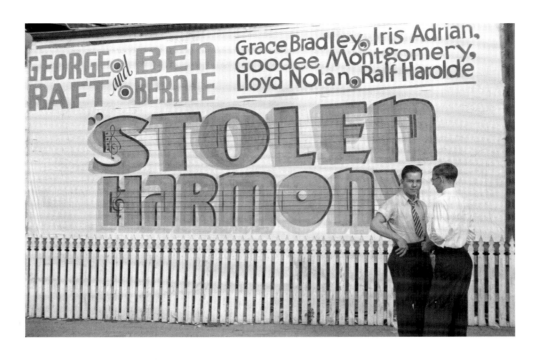

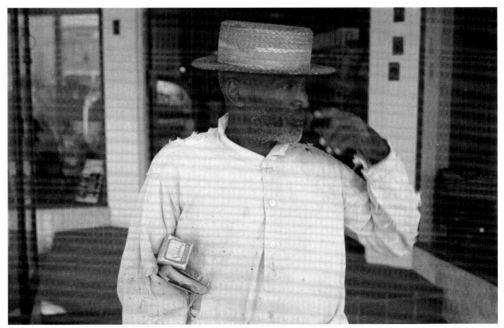

PLATE 14. "Signboard in Amite City, Louisiana." Ben Shahn, Oct. 1935.

PLATE 15. "Resident of Amite City, Louisiana." Ben Shahn, Oct. 1935.

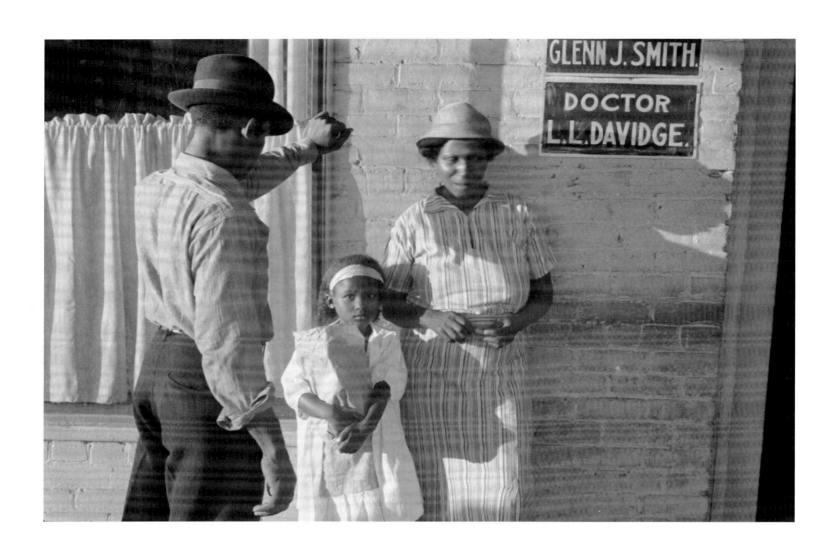

PLATE 16. "Residents of Amite City, Louisiana." Ben Shahn, Oct. 1935.

42

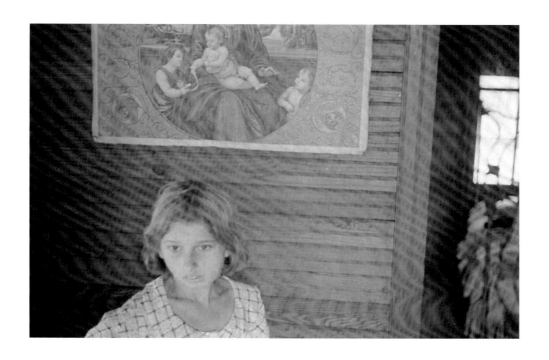

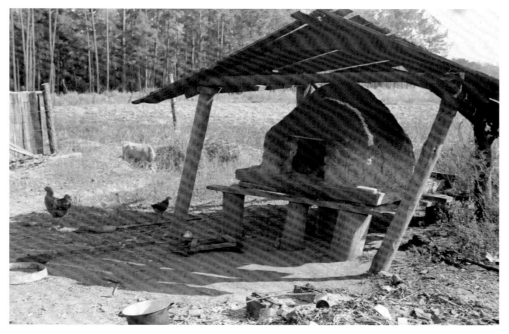

PLATE 17. "Child of Fortuna family, Hammond, Louisiana." Ben Shahn, Oct. 1935.

PLATE 18. "Oven for baking bread belonging to Fortuna family, Hammond, Louisiana." Ben Shahn, Oct. 1935.

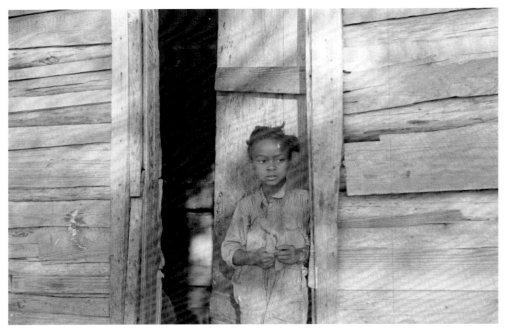

PLATE 19. "Untitled photo, possibly related to: Children of Fortuna family, Hammond, Louisiana." Ben Shahn, Oct. 1935. (The punched hole indicates this image was to be discarded.)

PLATE 20. "Child of strawberry picker, Hammond, Louisiana." Ben Shahn, Oct. 1935.

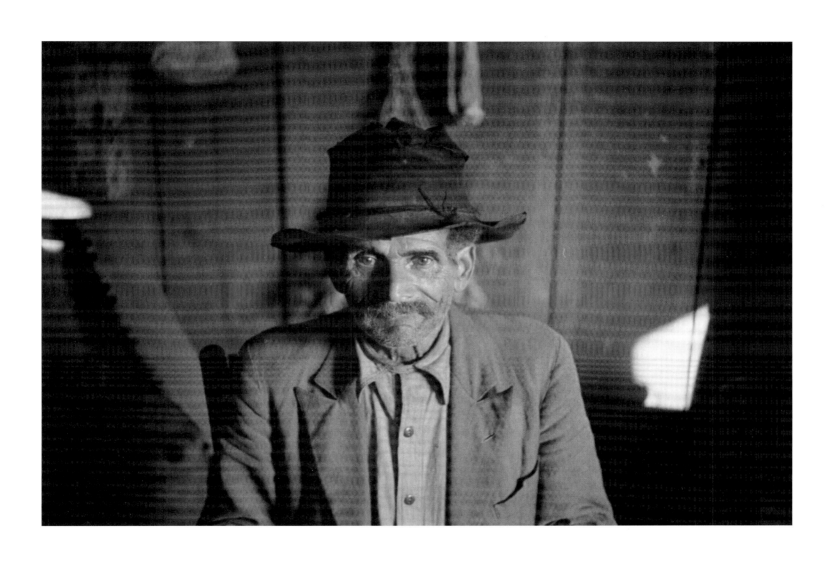

PLATE 21. "Strawberry picker, Hammond, Louisiana." Ben Shahn, Oct. 1935.

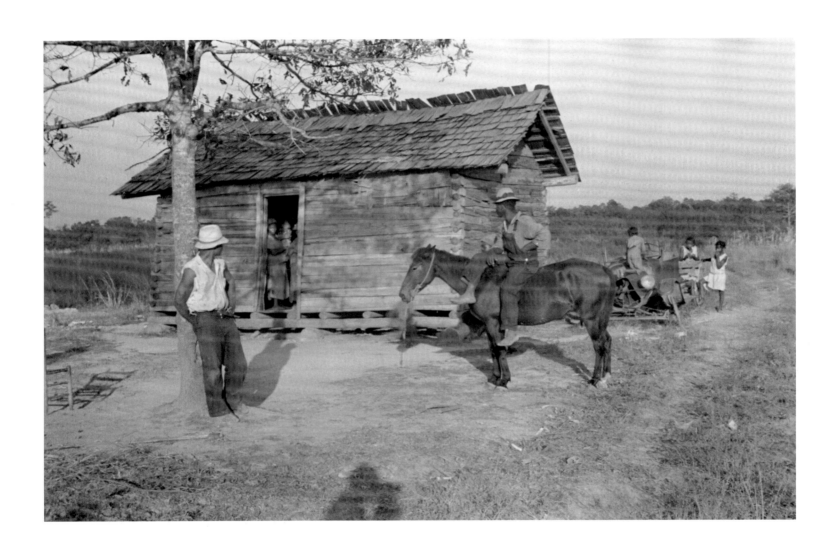

PLATE 22. "Untitled photo, possibly related to: Strawberry picker, Hammond, Louisiana." Ben Shahn, Oct. 1935.

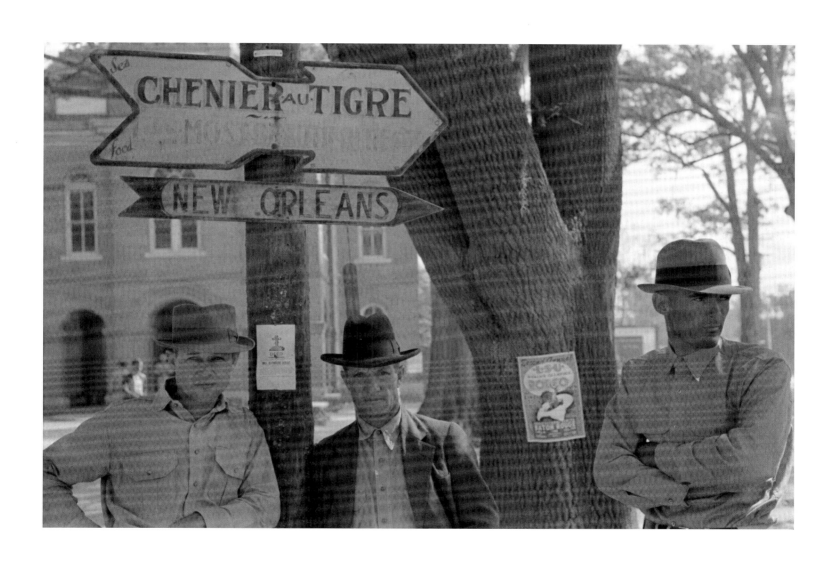

PLATE 23. "Men in front of courthouse, Abbeville, Louisiana." Russell Lee, Nov. 1938.

47

PLATE 24. "Negro stevedore carrying lumber on his head, New Orleans, Louisiana." Russell Lee, Sept. 1938.

PLATE 25. "Unloading oysters from packet boat arriving at New Orleans, Louisiana." Russell Lee, Sept. 1938.

PLATE 26. "Stairs and columns with brick masonry, remains of plantation house after fire, near Lutcher, Louisiana." Russell Lee, Sept–Oct. 1938.

PLATE 27. "Post office, Paulina, Louisiana." Russell Lee, Sept. 1938.

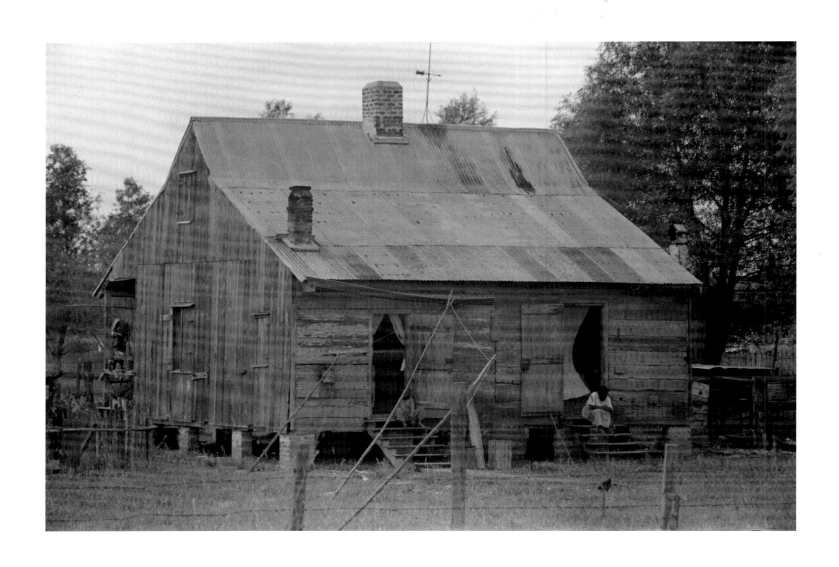

PLATE 28. "Negro shack near Convent, Louisiana." Russell Lee, Sept. 1938.

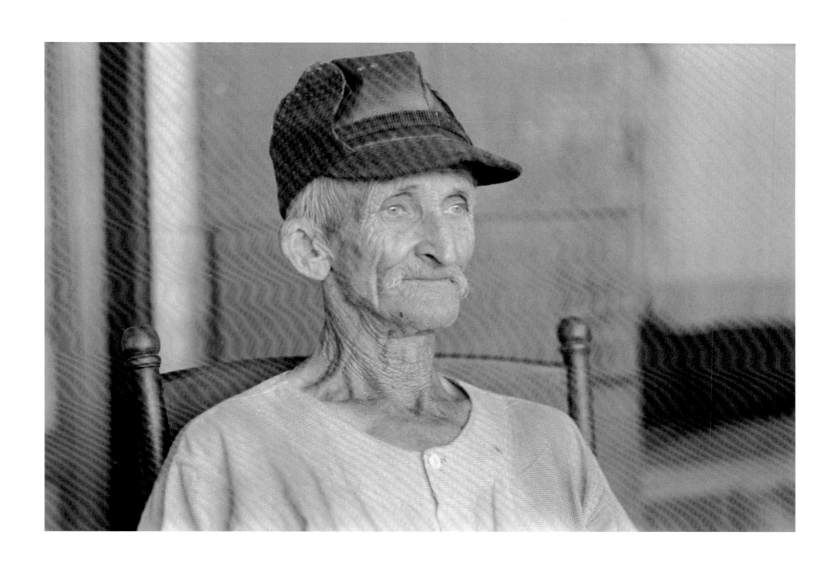

PLATE 29. "Old farmer near Lutcher, Louisiana." Russell Lee, Oct. 1938.

51

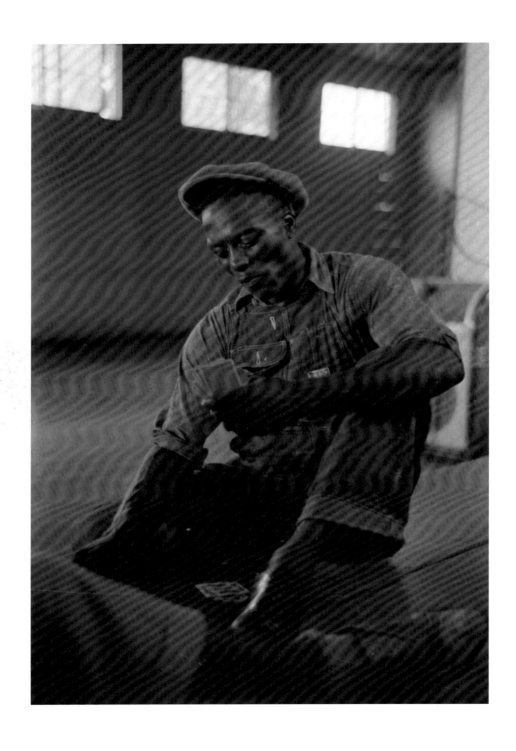

PLATE 30. "Untitled photo, possibly related to: Game of coon-can in store near Reserve, Louisiana." Russell Lee, Sept. 1938.

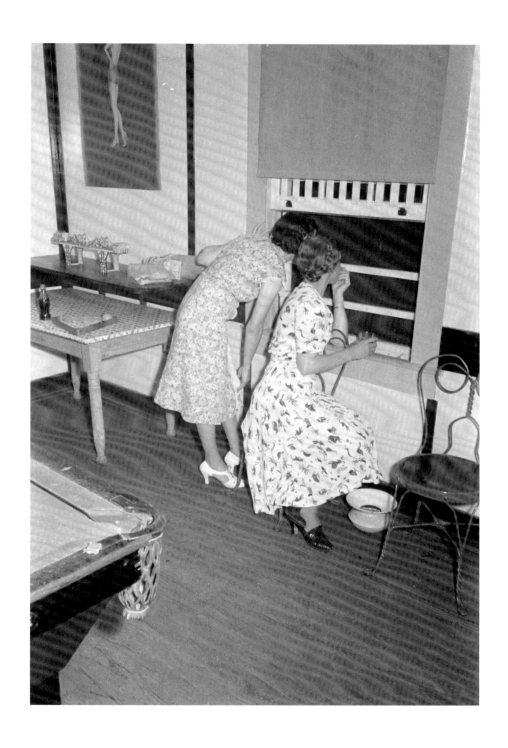

PLATE 31. "Looking for the boat from window of combined bar and pool room, Pilottowr, Louisiana." Russell Lee, Sept. 1938.

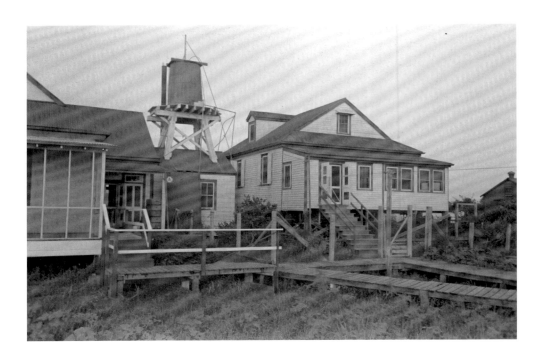

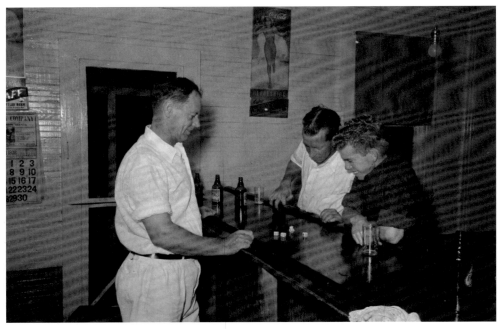

PLATE 32. "Pilottown, Louisiana, building and boardwalks." Russell Lee, Sept. 1938.

PLATE 33. "Playing game of 'horses' with dice-shaking for the drinks, Pilottown, Louisiana." Russell Lee, Sept. 1938.

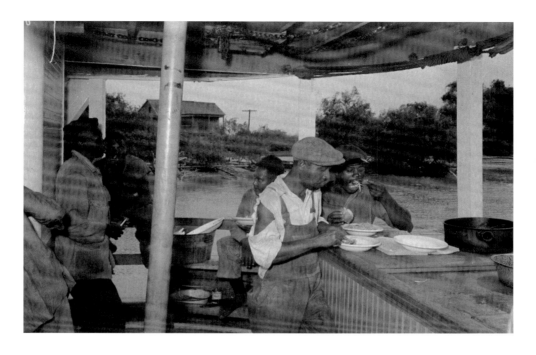

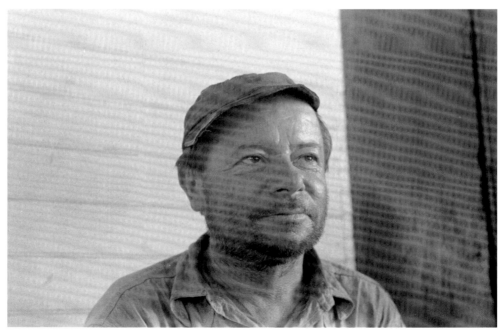

PLATE 34. "Negro stevedores eating on stern of boat. Food supplied to crew consists almost entirely of carbohydrates with some of the cheaper cuts of meat. Sleeping quarters are not provided for stevedores, who sleep in any available space. Aboard El Rito, Pilottown, Louisiana." Russell Lee, Sept. 1938.

PLATE 35. "Resident of Olga, Louisiana, a Russian emigrant." Russell Lee, Sept. 1938.

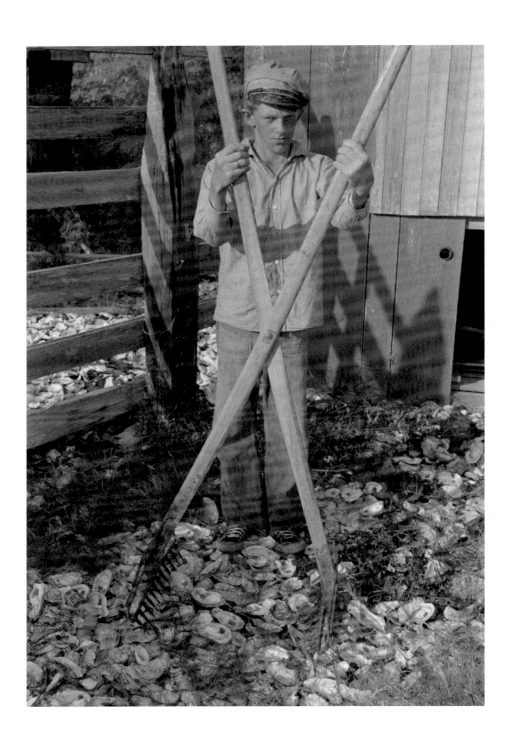

PLATE 36. "Boy with oyster rake used for scooping oysters in fishing operations, Olga, Louisiana." Russell Lee, Sept. 1938.

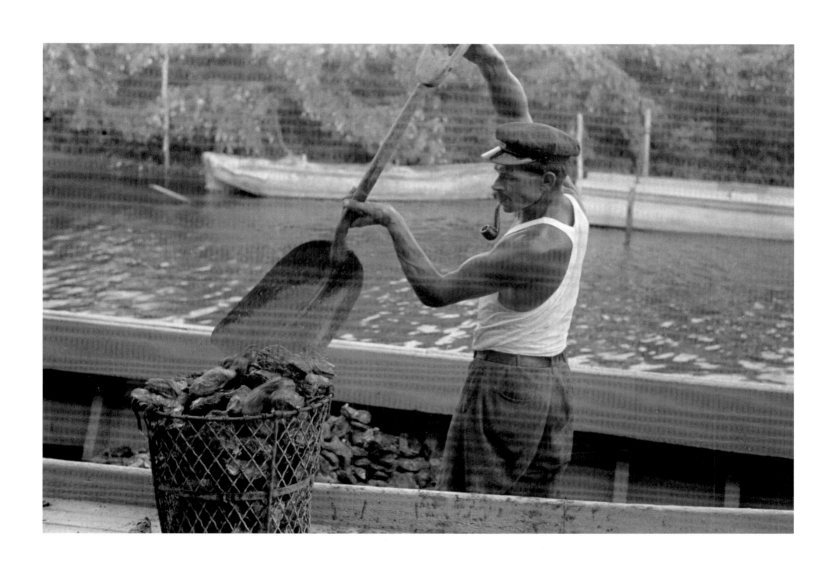

PLATE 37. "Unloading oysters from boat, Olga, Louisiana." ussell Lee, Sept. 1938.

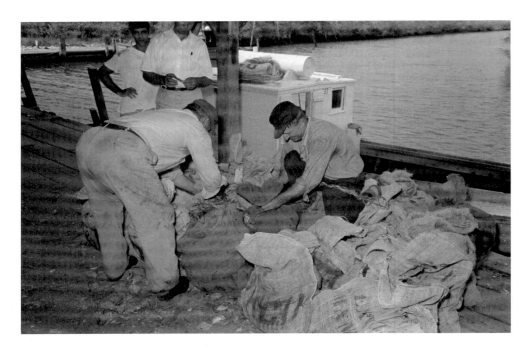

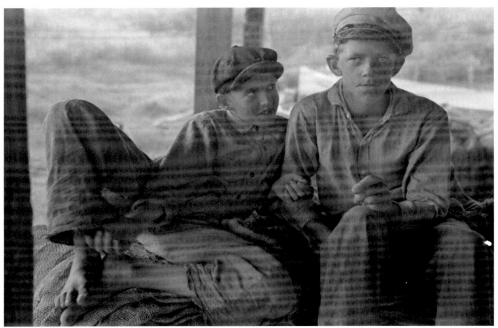

PLATE 38. "Tying sacks of oysters and attaching tags, Olga, Louisiana." Russell Lee, Sept. 1938.

PLATE 39. "Sons of fishermen, Olga, Louisiana." Russell Lee, Sept. 1938.

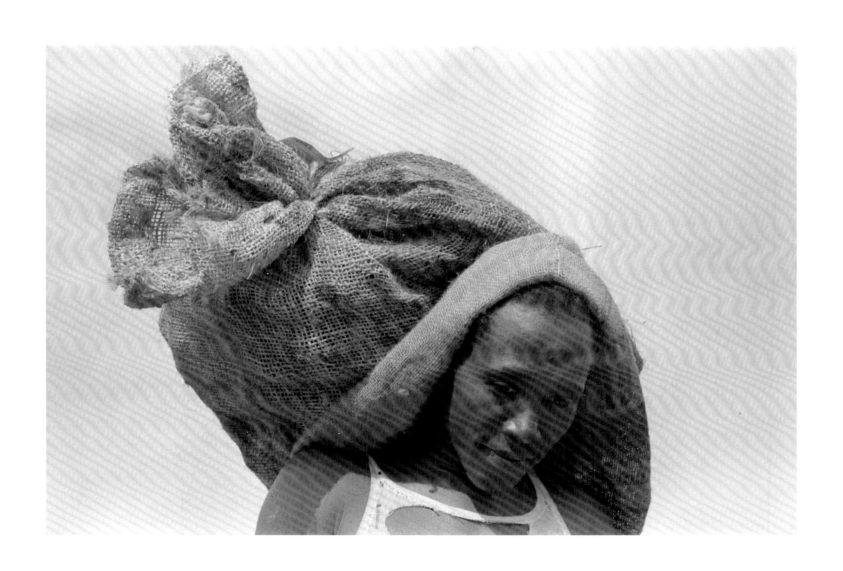

PLATE 40. "Negro stevedore with sack of oysters, Olga, Louisiana." Russell Lee, Sept. 1938.

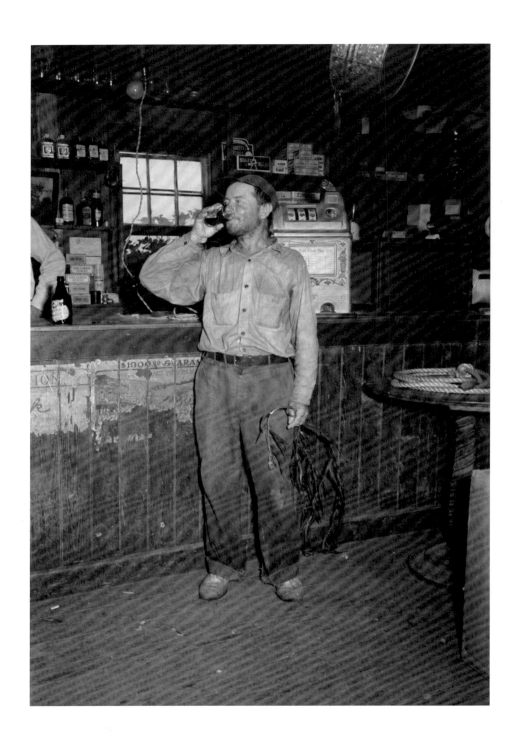

PLATE 41. "Native of Olga, Louisiana drinking at the bar. Note the branch of tree used as a mosquito switch." Russell Lee, Sept. 1938.

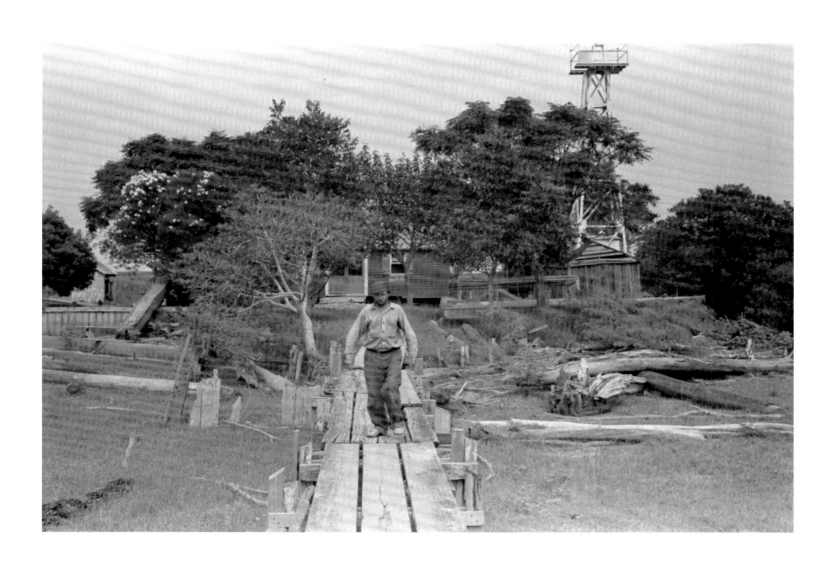

PLATE 42. "Untitled photo, possibly related to: Negro stevedores returning to boat after unloading cargo at Venice, Louisiana." Russell Lee, Sept. 1938.

PLATE 43. "Front yard of orange grower, Boothville, Louisiana." Russell Lee, Sept. 1938.

PLATE 44. "Church in the orange growing section, Boothville, Louisiana." Russell Lee, Sept. 1938.

PLATE 45. "Residents at Boothville, Louisiana sitting on dock." Russell Lee, Sept. 1938.

63

PLATE 46. "Drinking at the bar, crab boil night, Raceland, Louisiana." Russell Lee, Sept. 1938.

PLATE 47. "Negro church near Paradis, Louisiana." Russell Lee, Sept. 1938.

PLATE 48. "Outdoor cistern of house near River Road, near Destrehan, Louisiana. These open cisterns are a great breeding place for mosquitoes and are prevalent throughout southern Louisiana." Russell Lee, Sept. 1938.

PLATE 49. "Barber pole on tree and sign, Kenner, Louisiana." Russell Lee, Sept. 1938.

PLATE 50. "Fisherman's home along the Bayou, Akers, Louisiana." Russell Lee, Oct. 1938.

PLATE 51. "Traveling evangelists pushing cart on road between Lafayette and Scott, Louisiana." Russell Lee, Oct. 1938.

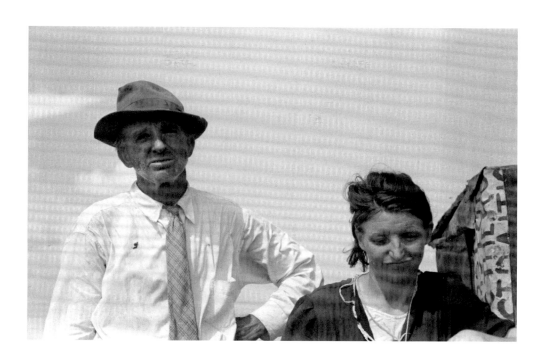

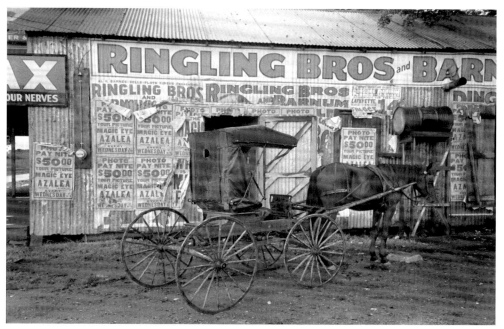

PLATE 52. "Untitled photo, possibly related to: Traveling evangelists between Lafayette and Scott, Louisiana.
They have spent twenty five years on the road preaching the gospel, sharpening knives to meet expenses." Russell Lee, Oct. 1938.

PLATE 53. "Horse and buggy standing in front of store near Lafayette, Louisiana." Russell Lee, Oct. 1938.

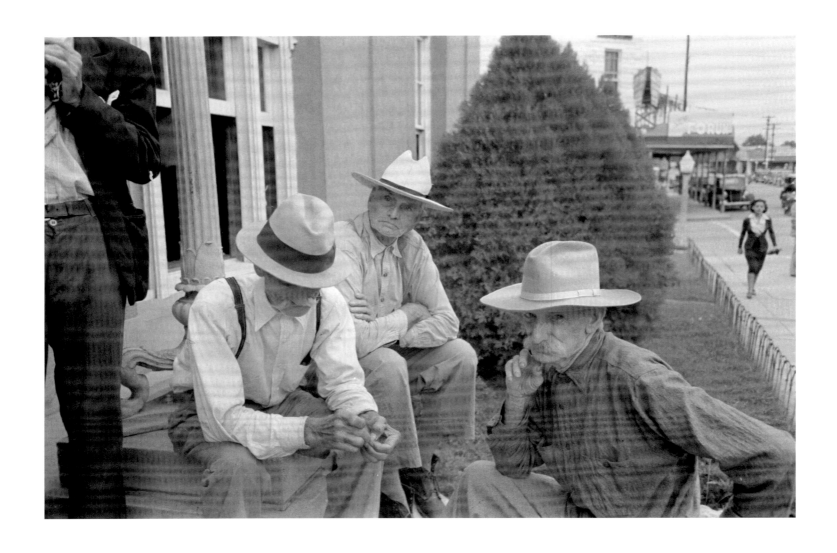

PLATE 54. "Old-timers sitting on post office steps, Lafayette, Louisiana." Russell Lee, Oct. 1938.

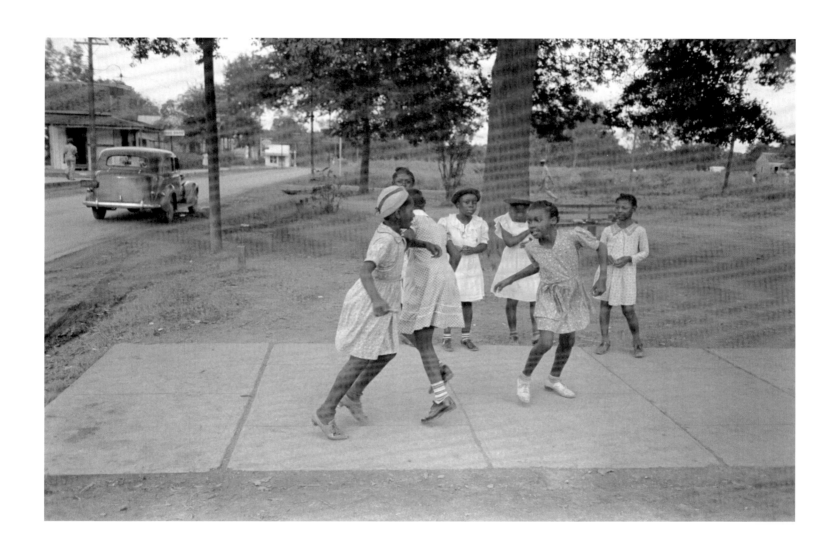

PLATE 55. "Little Negro girls playing, Lafayette, Louisiana." Russell Lee, Oct. 1938.

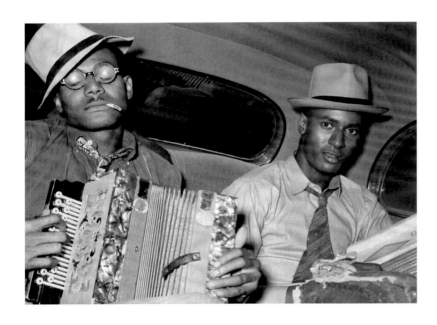

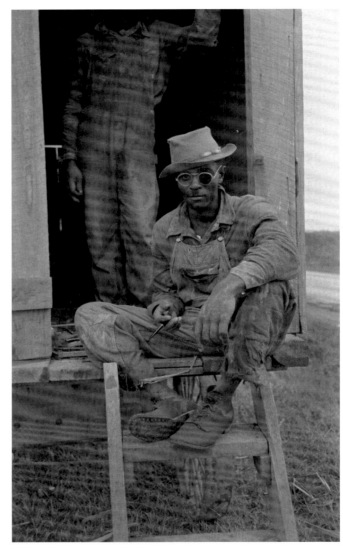

PLATE 56. "Negro musicians playing accordion and washboard in automobile. Near New Iberia, Louisiana." Russell Lee, Oct. 1938.

PLATE 57. "Negro sitting in wagon which is moved in the fields to be used for protection from rain, sugarcane fields, New Iberia, Louisiana." Russell Lee, Oct. 1938.

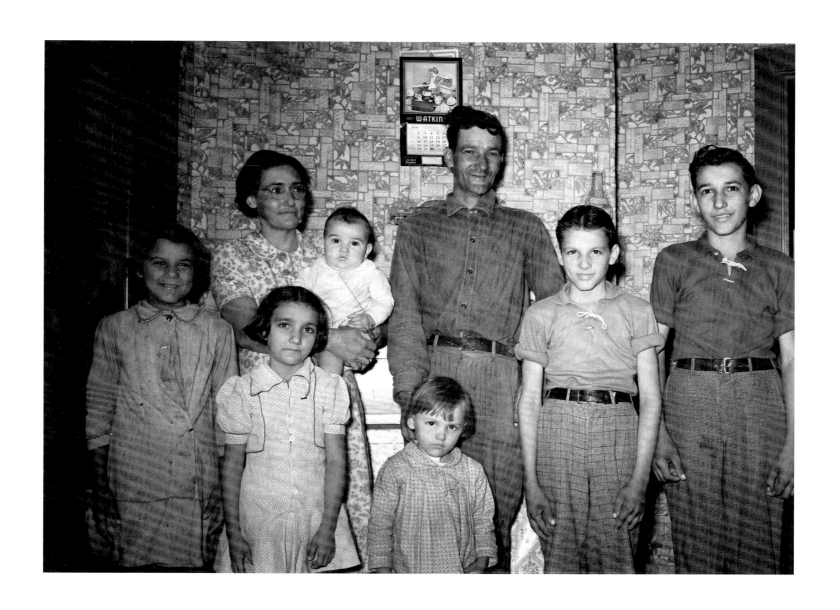

PLATE 58. "Family of Cajun farmer living near New Iberia, Louisiana. Mr. De Buis and wife have six children. They own twenty acres of ground on which there is a small, plainly furnished, but comfortable house. He is a young, enterprising farmer. He raises cane and some corn for feed. He has about 200 chickens, two cows and several hogs. He is very pessimistic over farm conditions, commenting 'What we going to do if they keep on cutting us down?'" Russell Lee, Oct. 1938.

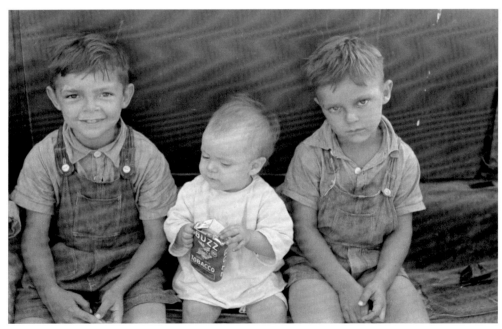

PLATE 59. "Laundry equipment and grain grinder on farm of Cajun sugarcane farmer near New Iberia, Louisiana." Russell Lee, Oct. 1938.

PLATE 60. "Children of day laborer work in cane fields near New Iberia, Louisiana." Russell Lee, Oct. 1938.

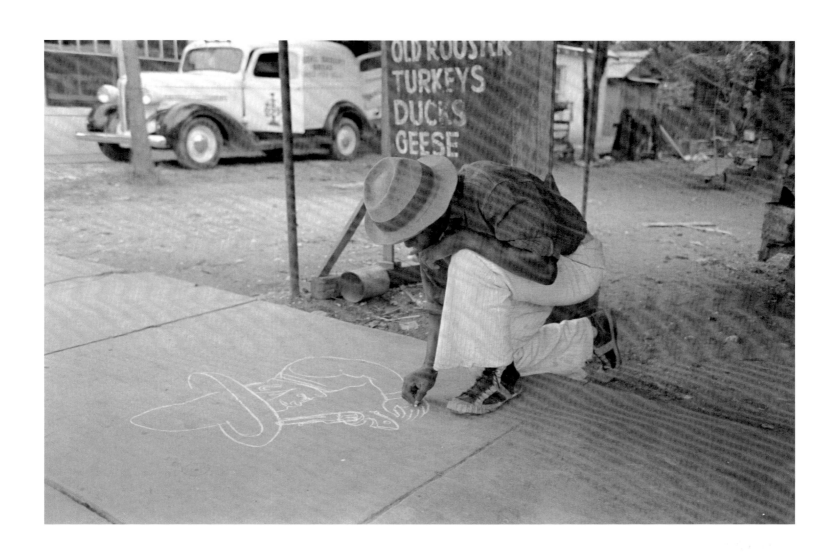

PLATE 61. "Negro boy drawing on the sidewalk, New Iberia, Louisiana." Russell Lee, Oct. 1938.

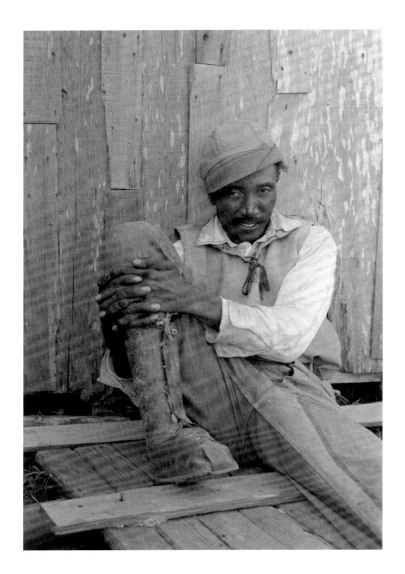

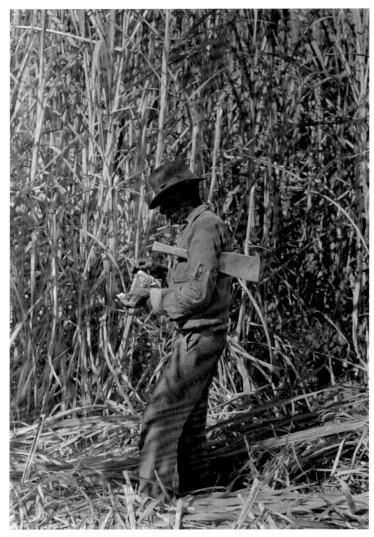

PLATE 62. "Untitled photo, possibly related to: Negro sugar caneworker, Louisiana." Russell Lee, Oct. 1938.

PLATE 63. "Negro sugarcane cutter rolling a cigarette in field near New Iberia, Louisiana." Russell Lee, Oct. 1938.

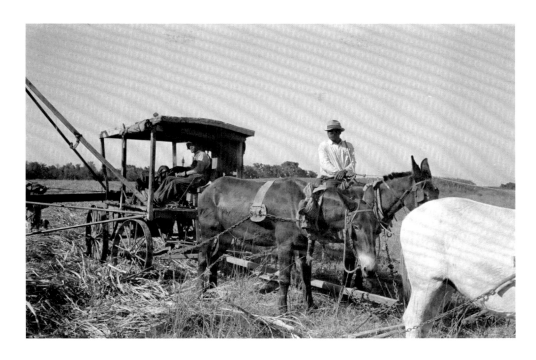

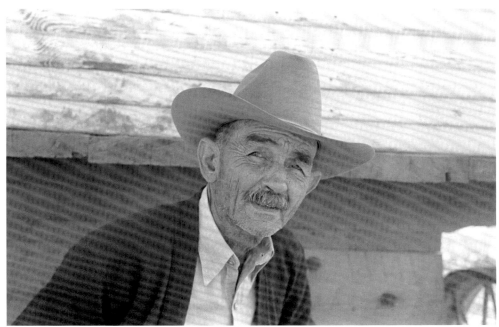

PLATE 64. "Part of machine developed by Negro for loading sugarcane onto trucks near New Iberia, Louisiana." Russell Lee, Oct. 1938.

PLATE 65. "Foreman on sugar plantation, Louisiana." Russell Lee, Oct. 1938.

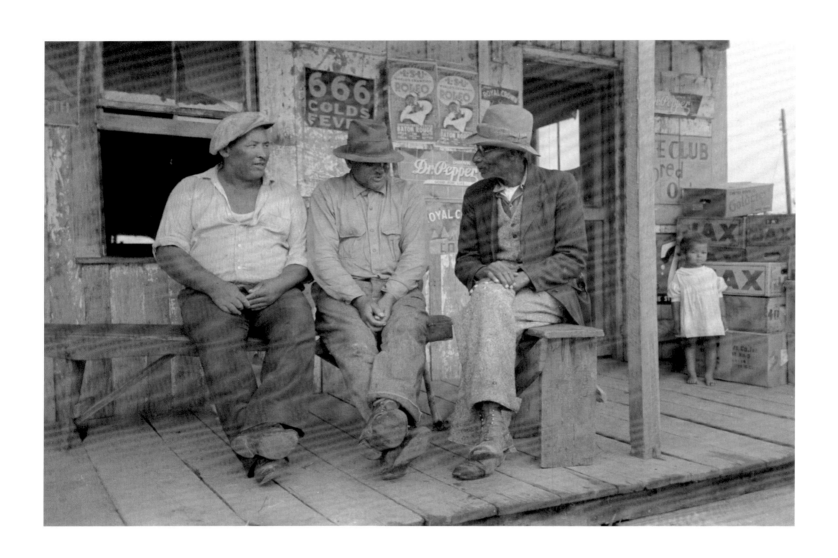

PLATE 66. "Untitled photo, possibly related to: Negroes talking on porch of small store near Jeanerette, Louisiana." Russell Lee, Oct. 1938.

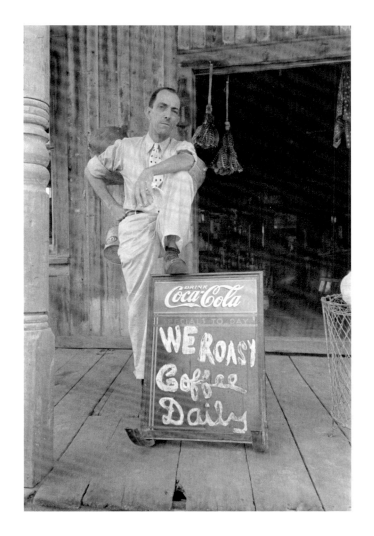

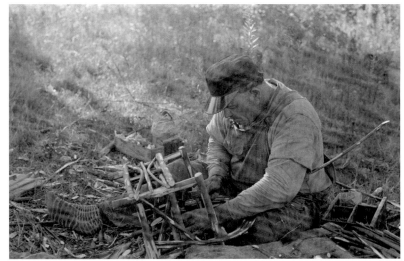

PLATE 67. "Proprietor of small grocery store, Jeanerette, Louisiana." Russell Lee, Oct. 1938.

PLATE 68. "Migrant cane chair maker on U.S. 90 near Jeanerette, Louisiana." Russell Lee, Oct. 1938.

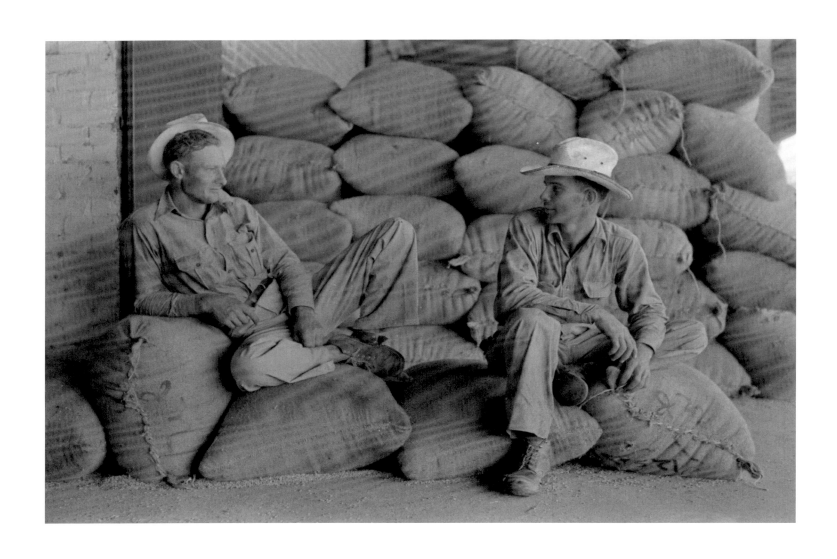

PLATE 69. "Farmers sitting on bags of rice, state mill, Abbeville, Louisiana." Russell Lee, Sept. 1938.

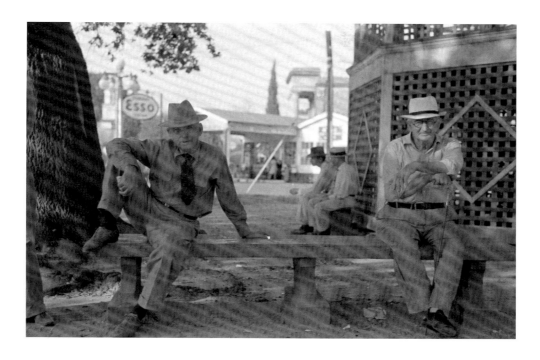

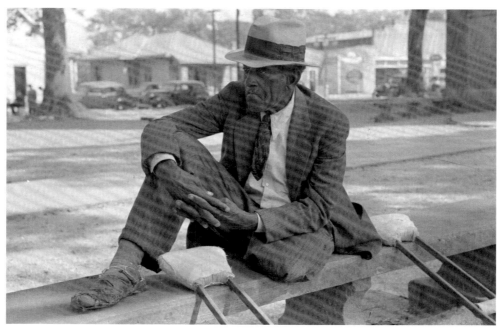

PLATE 70. "Men sitting on bench in front of bandstand in courthouse square, New Iberia, Louisiana." Russell Lee, Nov. 1938.

PLATE 71. "Crippled man sitting on bench in front of courthouse, Abbeville, Louisiana." Russell Lee, Nov. 1938.

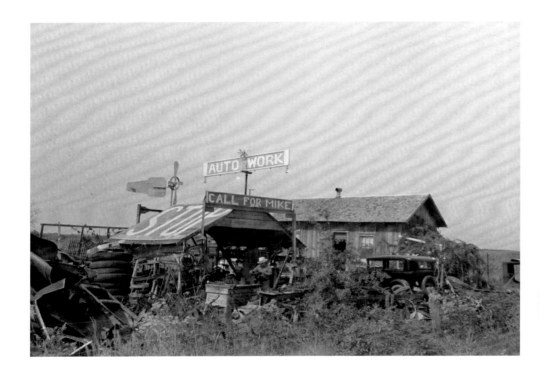

PLATE 72. "Junkyard, near Abbeville, Louisiana." Russell Lee, Nov. 1938.

PLATE 73. "Painted sign on side of store, Abbeville, Louisiana." Russell Lee, Nov. 1938.

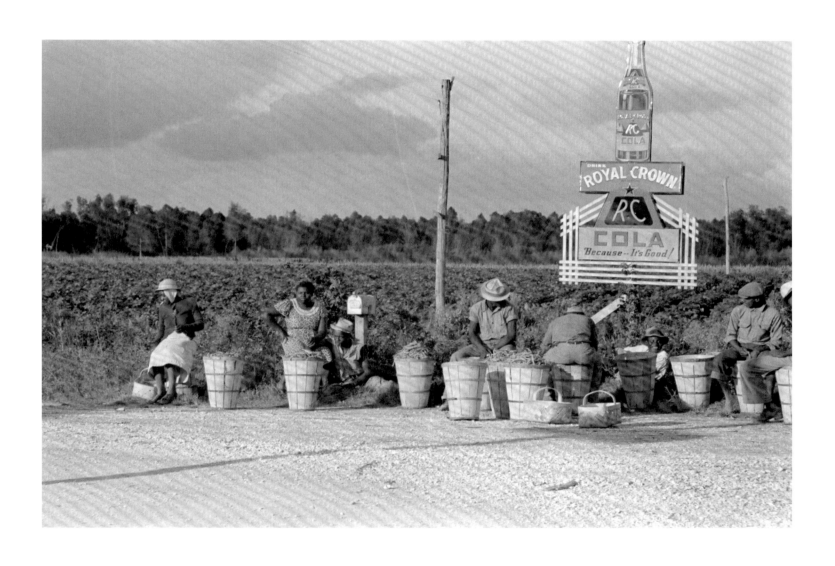

PLATE 74. "String bean pickers waiting along highway for trucks to pick them up near Gibson, Louisiana." Russell Lee, Oct. 1938.

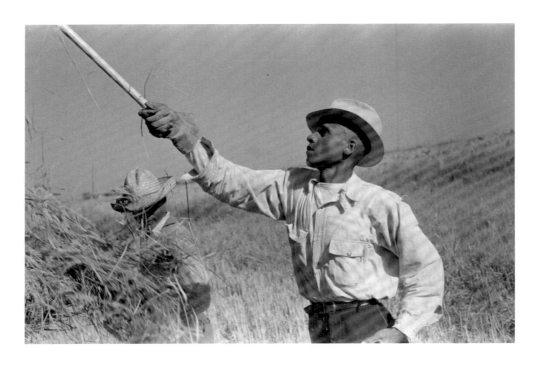

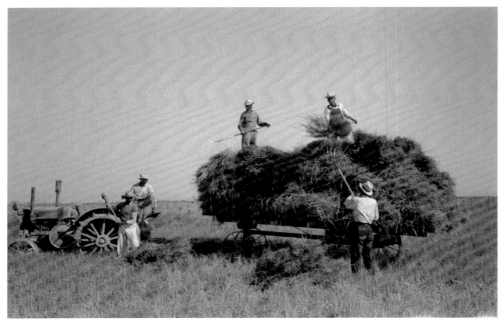

PLATE 75. "Untitled photo, possibly related to: Pitching bundles of rice from rack to wagon.
Note how bundle is caught in midair by worker atop wagon. Crowley, Louisiana." Russell Lee, Sept. 1938.

PLATE 76. "Harvesting rice, Crowley, Louisiana." Russell Lee, Sept. 1938.

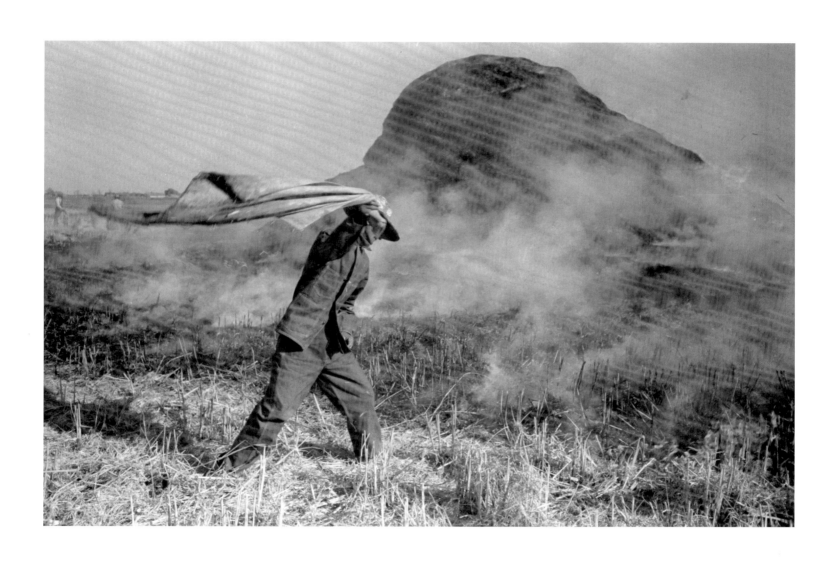

PLATE 77. "Fighting fire of rice straw stack in rice field near Crowley, Louisiana." Russell Lee, Sept. 1938.

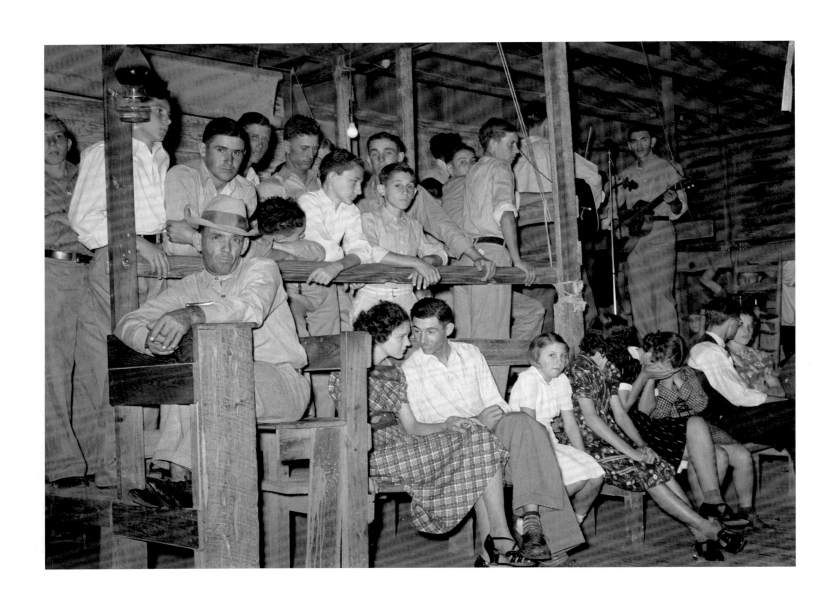

PLATE 78. "Men's section at fais-do-do near Crowley, Louisiana. Note ticket taker." Russell Lee, Oct. 1938.

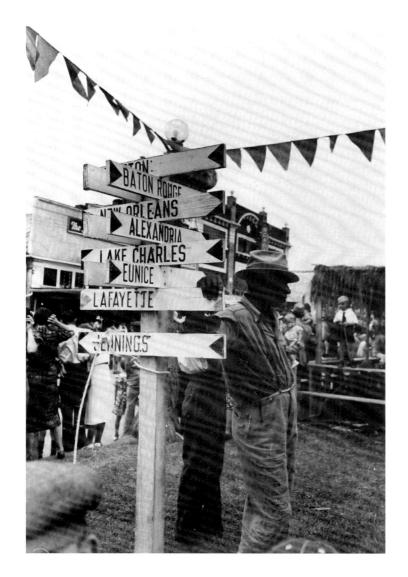
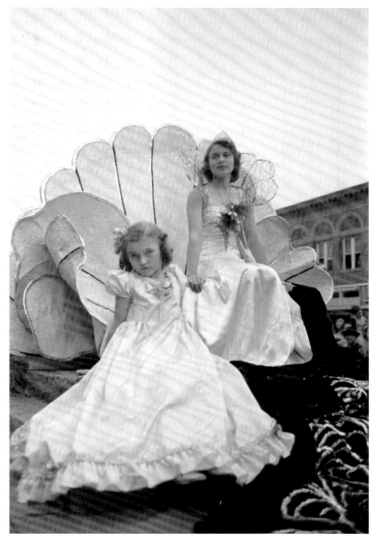

PLATE 79. "Highway direction markers, Crowley, Louisiana." Russell Lee, Oct. 1938.

PLATE 80. "Untitled photo, possibly related to: Queen and attendant on float, National Rice Festival, Crowley, Louisiana." Russell Lee, Oct. 1938.

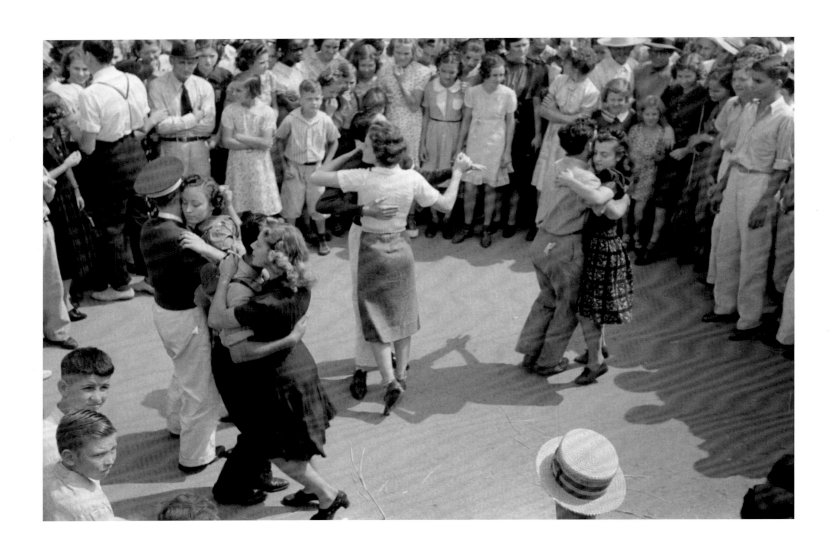

PLATE 81. "Street dance, National Rice Festival, Crowley, Louisiana." Russell Lee, Oct. 1938.

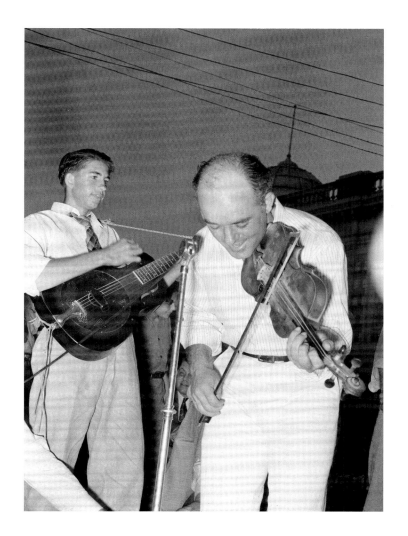

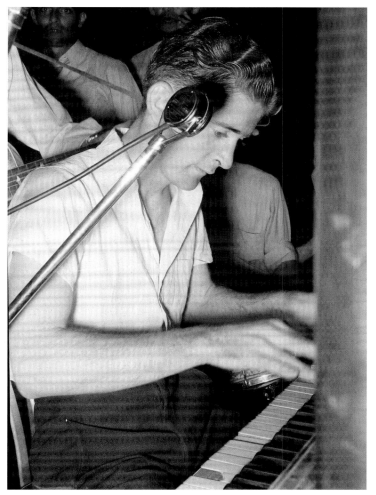

PLATE 82. "Musicians in Cajun band contest, National Rice Festival, Crowley, Louisiana. Most of the music was of the folk variety accompanied by singing." Russell Lee, Oct. 1938.

PLATE 83. "Pianist in cajun band contest. National Rice Festival, Crowley, Louisiana." Russell Lee, Oct. 1938.

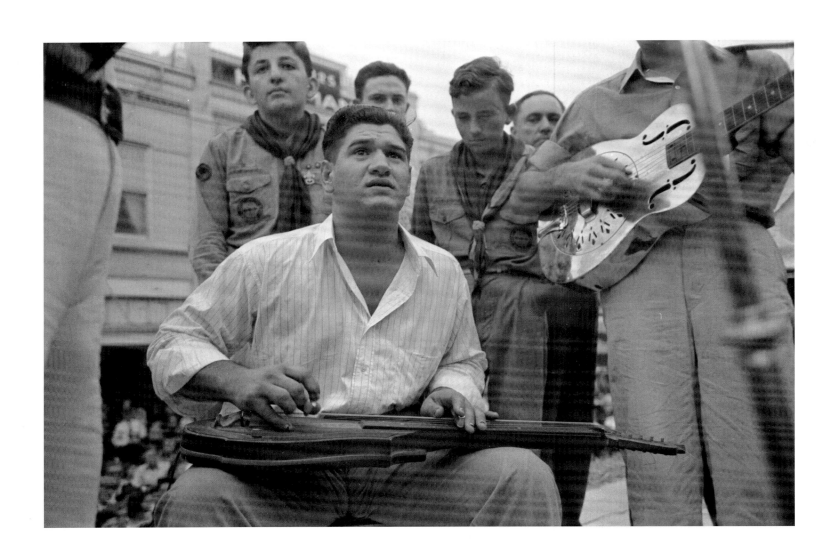

PLATE 84. "Cajun Hawaiian guitar player, National Rice Festival, Crowley, Louisiana." Russell Lee, Oct. 1938.

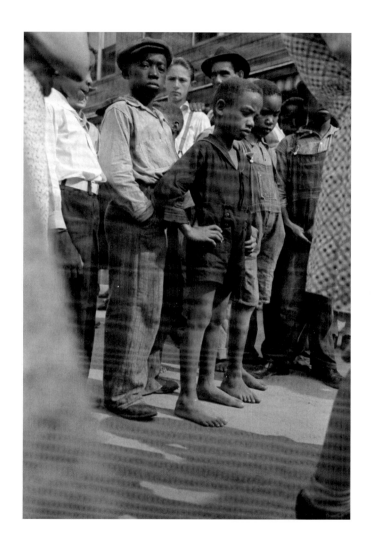

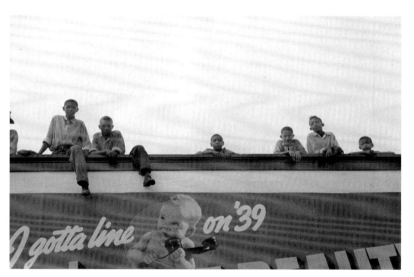

PLATE 85. "Negro boys in crowd, National Rice Festival, Crowley, Louisiana." Russell Lee, Oct. 1938.

PLATE 86. "Negro boys atop billboard, National Rice Festival, Crowley, Louisiana." Russell Lee, Oct. 1938.

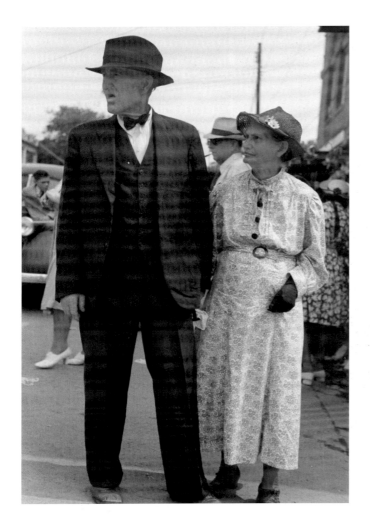

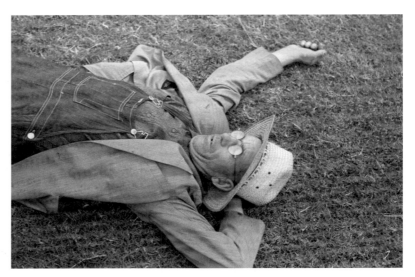

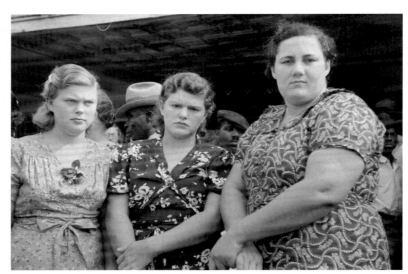

PLATE 87. "Spectators at National Rice Festival, Crowley, Louisiana." Russell Lee, Oct. 1938.

PLATE 88. "Farmer at National Rice Festival taking a rest, Crowley, Louisiana." Russell Lee, Oct.1938.

PLATE 89. "Cajun girls at Rice Festival, Crowley, Louisiana." Russell Lee, Oct. 1938.

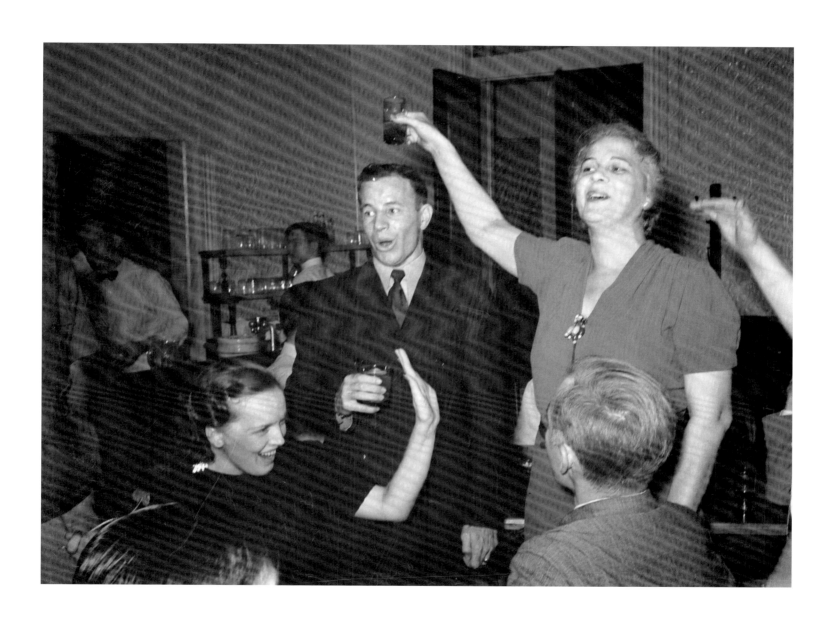

PLATE 90. "Singing at the bar during the National Rice Festival. Crowley, Louisiana." Russell Lee, Oct. 1938.

PLATE 91. "Detail of construction on hundred-year-old mud and moss chimney of farmhome of aged Cajun couple living near Crowley, Louisiana." Russell Lee, Nov. 1938.

PLATE 92. "Wealthy Cajun farm family sitting on porch of their new modern home near Crowley, Louisiana. Joseph La Blanc family." Russell Lee, Nov. 1938.

PLATE 93. "Untitled photo, possibly related to: Woman decorating family burial vaults in cemetery at New Roads, Louisiana on All Saints' Day." Russell Lee, Nov. 1938.

PLATE 94. "Painting grave marker in cemetery, All Saints' Day in New Roads, Louisiana." Russell Lee, Nov. 1938.

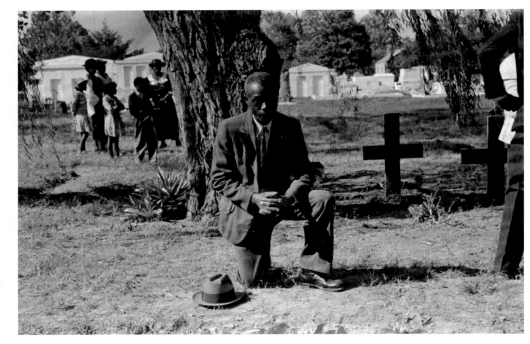

PLATE 95. "Decorated gravemarker on All Saints' Day, New Roads, Louisiana. Note the beaded ornament, which is made of wire and beads." Russell Lee, Nov. 1938.

PLATE 96. "Untitled photo, possibly related to: Negro crossing himself and praying over grave of relative in cemetery, All Saints' Day, New Roads, Louisiana." Russell Lee, Nov. 1938.

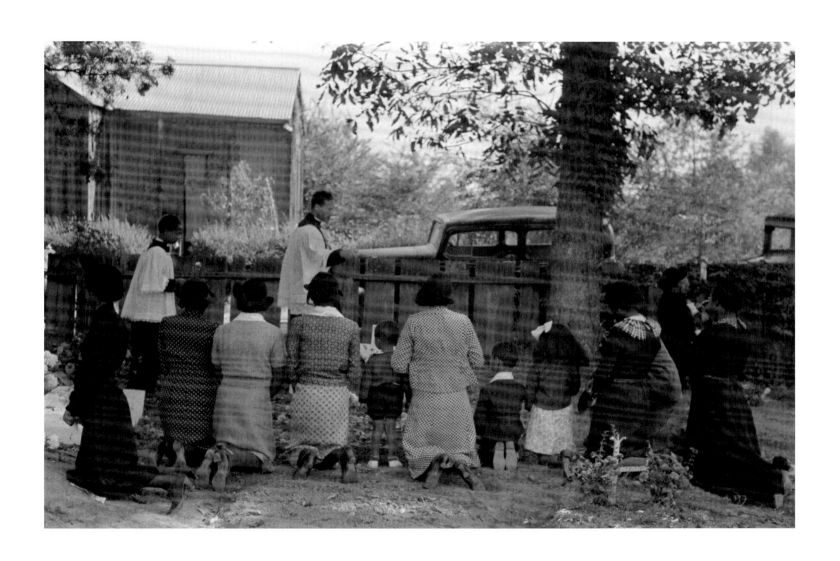

PLATE 97. "Negroes kneeling at graves of relatives, and being blessed by priest with holy water, New Roads, Louisiana." Russell Lee, Nov. 1938.

97

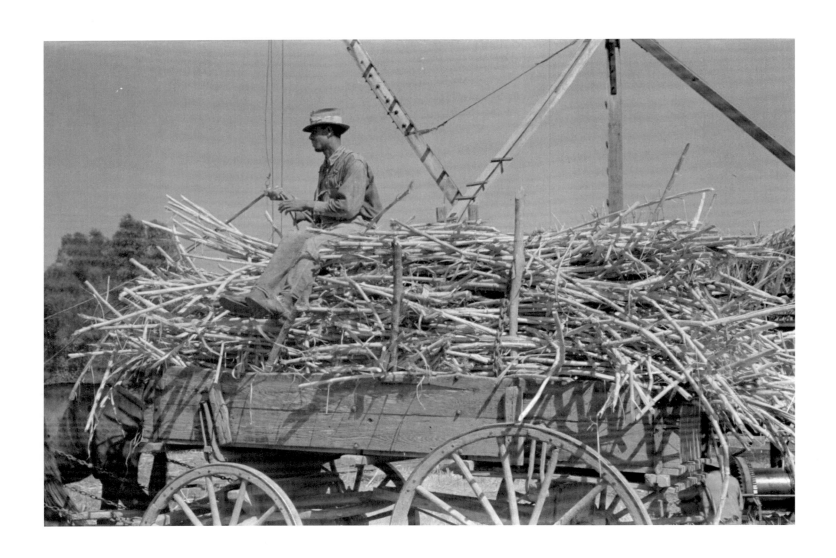

PLATE 98. "Farmer atop load of sugarcane, New Roads, Louisiana." Russell Lee, Nov. 1938.

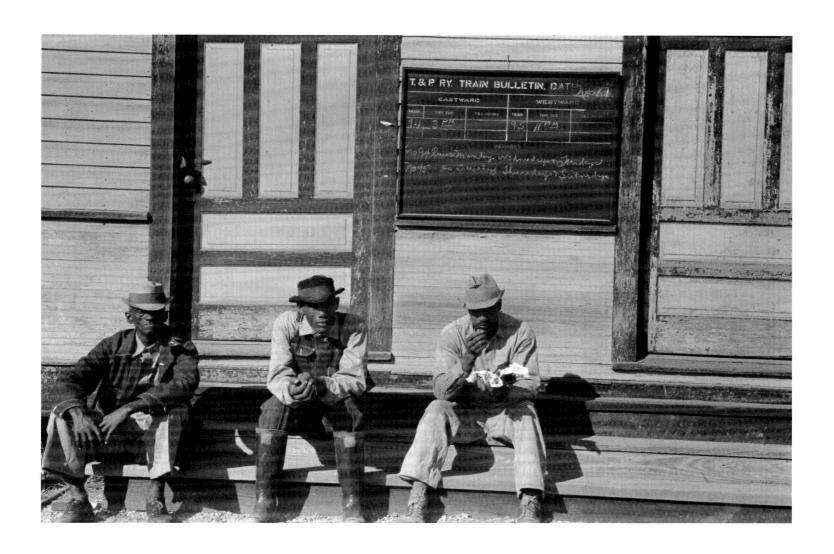

PLATE 99. "Negroes sitting on foot of the T&P (Texas and Pacific) railroad station, New Roads, Louisiana. Note frequency of train operations." Russell Lee, Nov. 1938.

PLATE 100. "Wife of small cane farmer near Jarreau, Louisiana, making mattress of moss." Russell Lee, Nov. 1938.

PLATE 101. "Farmer's wife washing clothes, near Morganza, Louisiana." Russell Lee, Nov. 1938.

PLATE 102. "Wife of FSA (Farm Security Administration) client who will participate in the tenant purchase pouring dishwater into slop pail, near Morganza, Louisiana." Russell Lee, Nov. 1938.

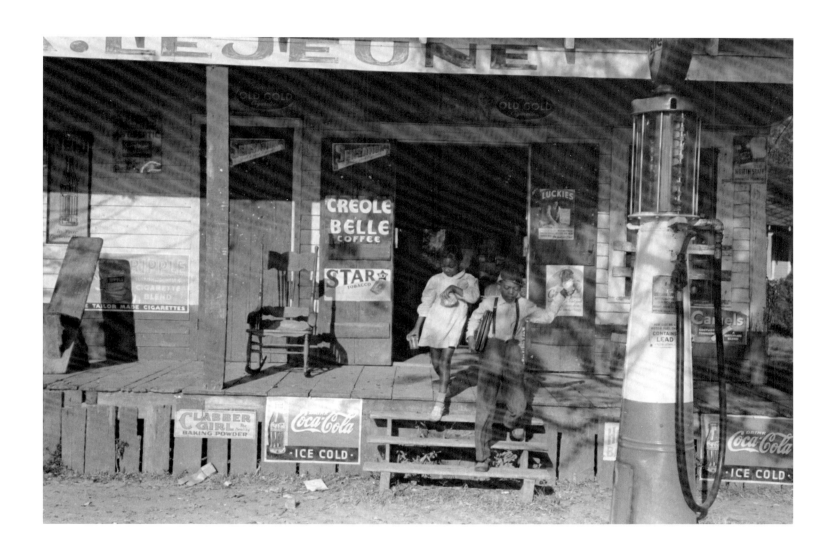

PLATE 103. "Negro children are coming out of store on way to school. Note lunches which they are carrying in hands. Mix, Louisiana." Russell Lee, Nov. 1938.

PLATE 104. "Notices of death, Saint Martinville, Louisiana. This is a very common custom to post these notices in the Southern states." Russell Lee, Nov. 1938.

PLATE 105. "Grotto in church. Saint Martinville, Louisiana. Sculpture work was done by local Negro." Russell Lee, Oct. 1938.

PLATE 106. "Interior of chapel near Donaldsonville, Louisiana." Russell Lee, Sept. 1938.

PLATE 107. "Man taking up flag in front of house to provide local atmosphere for state fair, Donaldsonville, Louisiana." Russell Lee, Nov. 1938.

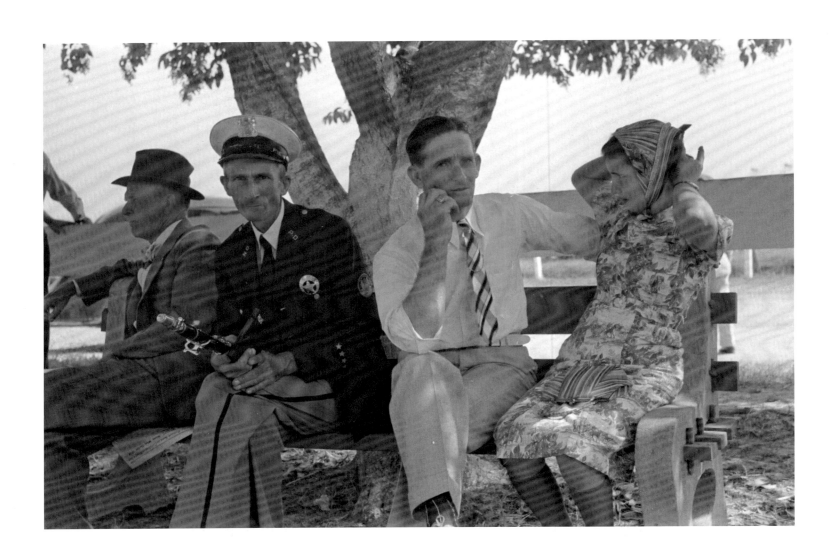

PLATE 108. "People sitting on bench, state fair, Donaldsonville, Louisiana." Russell Lee, Nov. 1938.

106

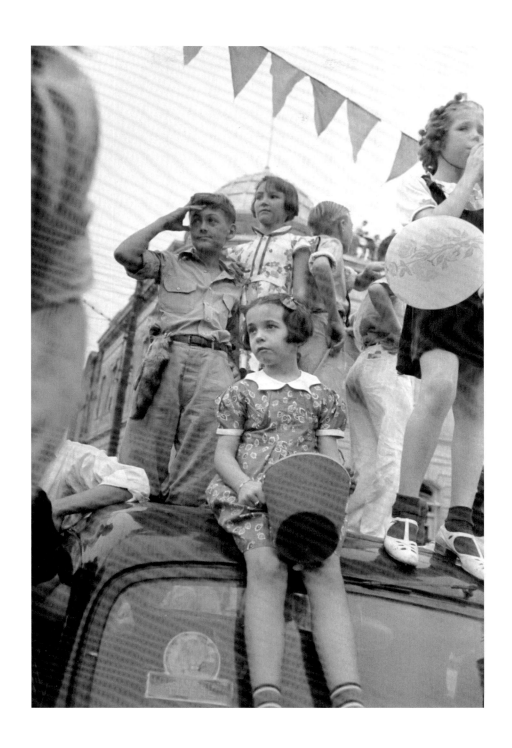

PLATE 109. "Untitled photo, possibly related to: Group of people at southern Louisiana state fair, Donaldsonville, Louisiana." Russell Lee, Nov. 1938.

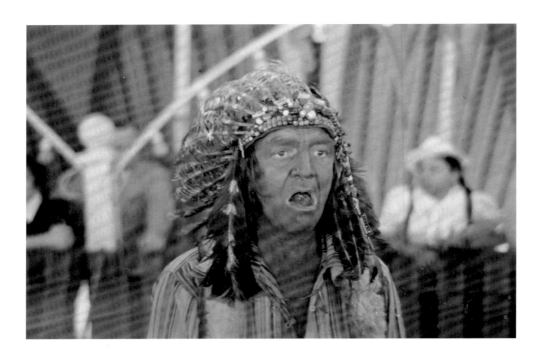

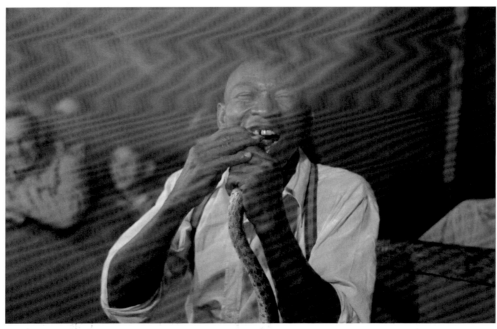

PLATE 110. "Indian glass eater, state fair, Donaldsonville, Louisiana." Russell Lee, Nov. 1938.

PLATE 111. "Man biting snake at sideshow, state fair, Donaldsonville, Louisiana." Russell Lee, Nov. 1938.

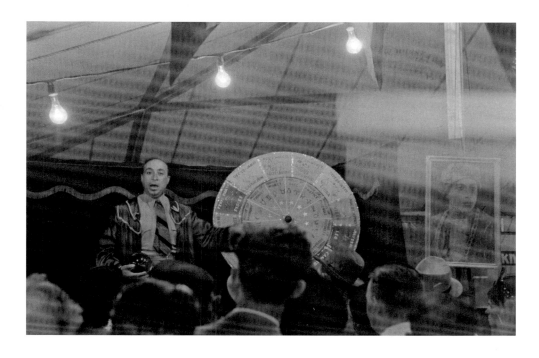

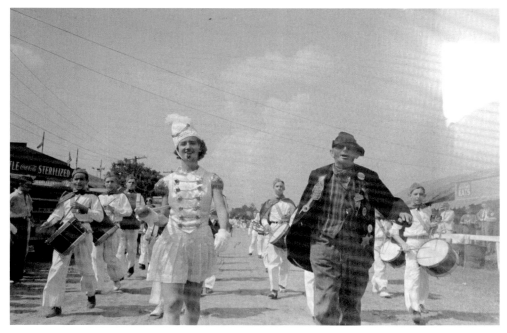

PLATE 112. "Fortune teller and mind reader in sideshow, state fair, Donaldsonville, Louisiana." Russell Lee, Nov. 1938.

PLATE 113. "Drum majorette with clown, leading parade of the drum corps, state fair, Donaldsonville, Louisiana." Russell Lee, Nov. 1938.

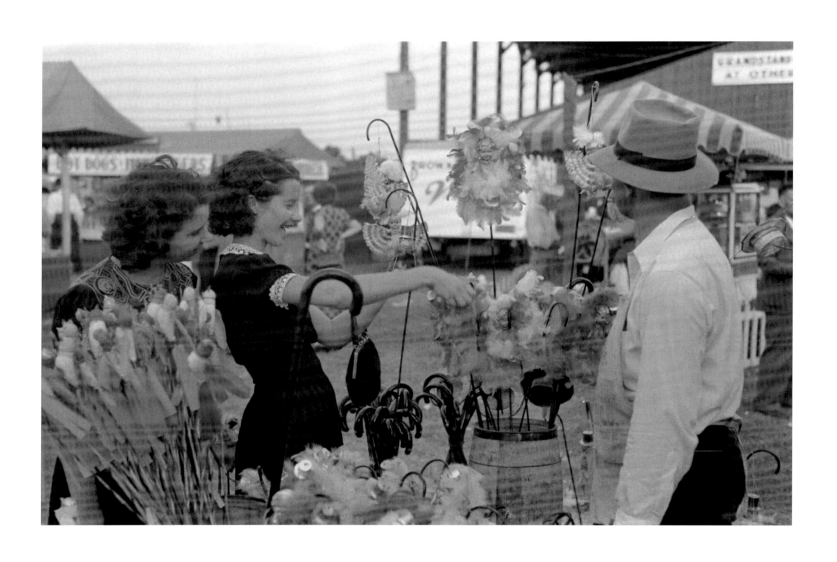

PLATE 114. "Girl buying cane from concessionaire, Donaldsonville, Louisiana, state fair." Russell Lee, Nov. 1938.

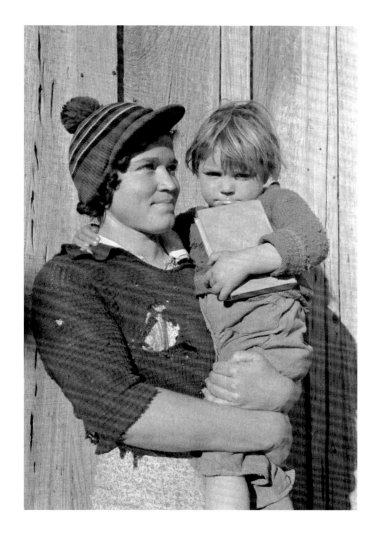 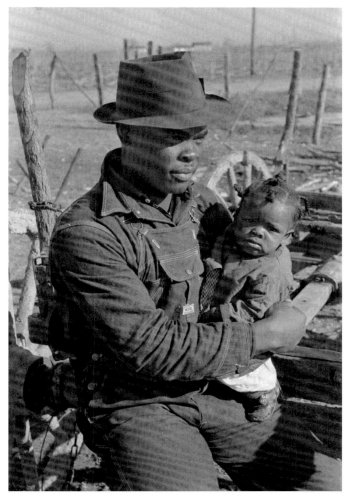

PLATE 115. "Mother and child who will be resettled, Transylvania Project, Louisiana." Russell Lee, Jan. 1939.

PLATE 116. "Negro sharecropper and child who will be resettled, Transylvania Project, Louisiana." Russell Lee, Jan. 1939.

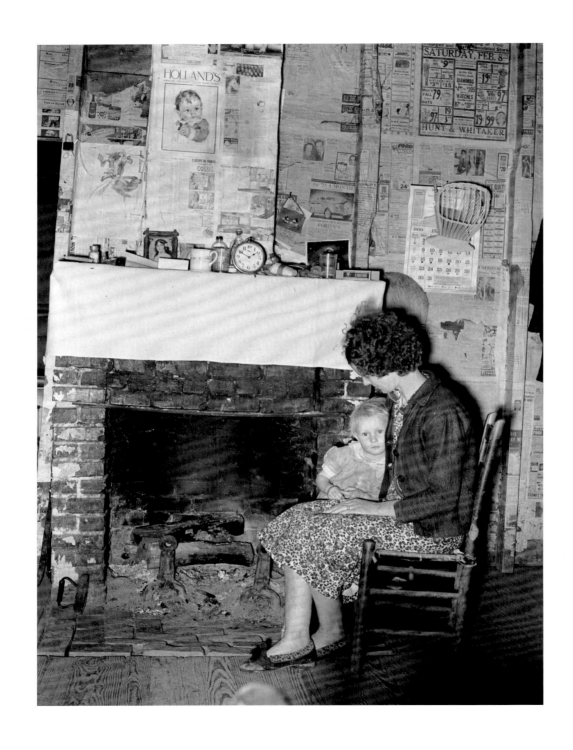

PLATE 117. "Wife and daughter of FSA (Farm Security Administration) client in front of fireplace of temporary home. Transylvania, Louisiana." Russell Lee, Jan. 1939.

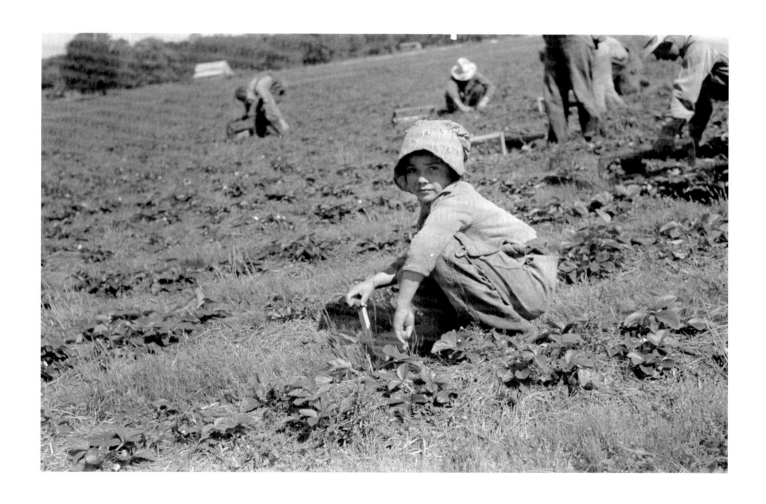

PLATE 118. "Child of white migrant strawberry picker, Hammond, Louisiana." Russell Lee, Apr. 1939.

113

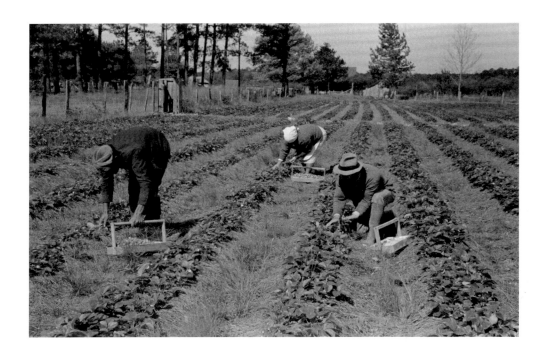

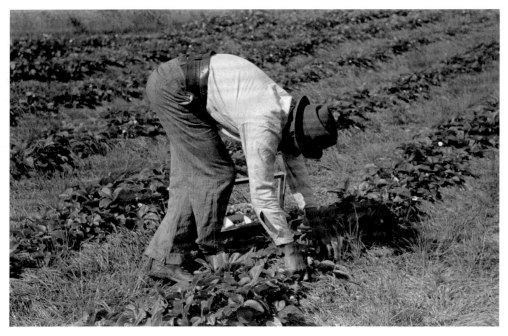

PLATE 119. "Negro intrastate migrant worker, Italian grower and his wife picking berries in field near Hammond, Louisiana." Russell Lee, Apr. 1939.

PLATE 120. "Colored intrastate migrant worker picking strawberries near Hammond, Louisiana." Russell Lee, Apr. 1939.

114

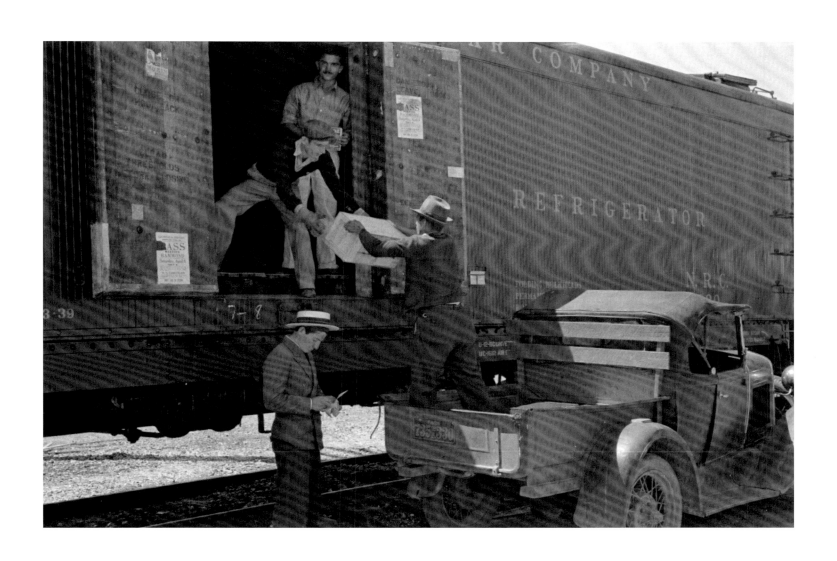

PLATE 121. "Loading strawberries into refrigerator car, Hammond, Louisiana." Russell Lee, Apr. 1939.

115

PLATE 122. "Fishing for crawfish, Opelousas, Louisiana." Russell Lee, Apr. 1939.

116

PLATE 123. "Buying dress goods in project cooperative store. Transylvania Project, Louisiana." Marion Post Wolcott, June 1940.

PLATE 124. "Baseball game on Saturday afternoon. Terrebonne Project, Schriever, Louisiana." Marion Post Wolcott, June 1940.

118

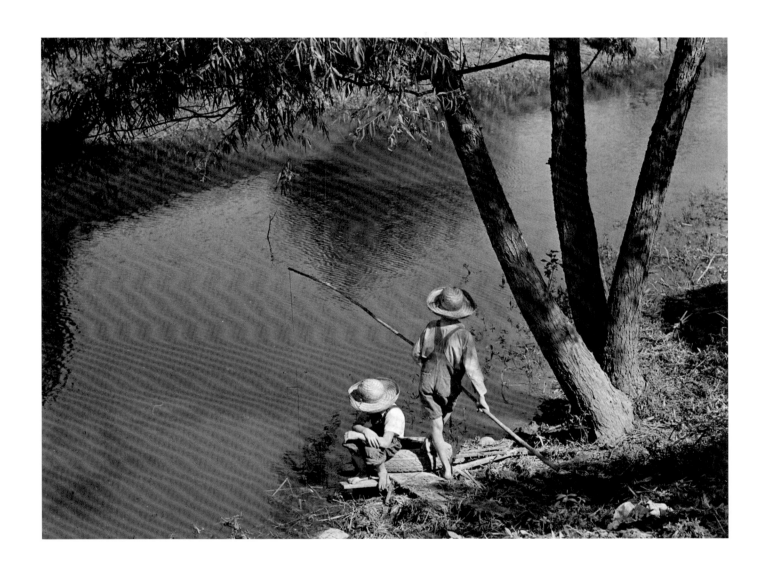

PLATE 125. "Cajun children fishing in a bayou near the school by Terrebonne Project. Schriever, Louisiana." Marion Post Wolcott, June 1940.

PLATE 126. "Farm family having fish fry along Cane River on Fourth of July near Natchitoches, Louisiana." Marion Post Wolcott, July 1940.

120

PLATE 127. "College boys trying to 'thumb' a ride home over the weekend, near Natchitoches, Louisiana." Marion Post Wolcott, June 1940.

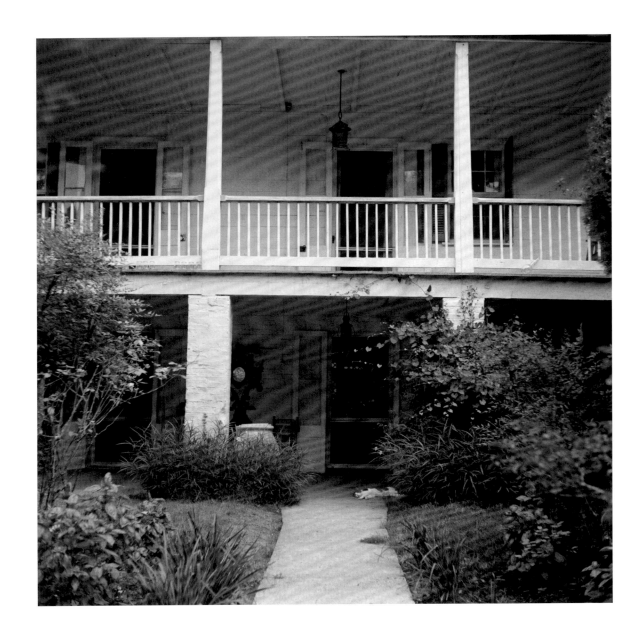

PLATE 128. "Melrose, Natchitoches Parish, Louisiana. Main house on the John Henry cotton plantation, which was built by mulatto Augustin Metoyier for his son Louis. It was originally called Yucca Plantation (from Spanish). See general caption." Marion Post Wolcott, June 1940.

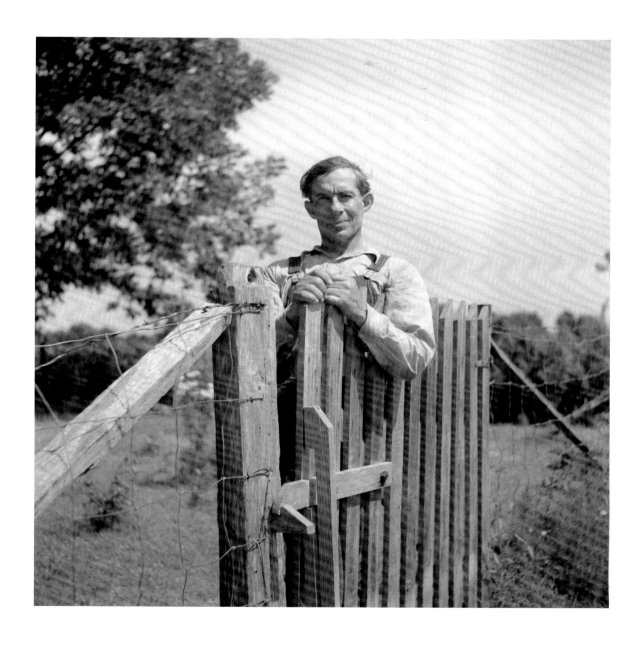

PLATE 129. "One of the mulattoes who works on the John Henry Plantation and is very skilled in woodwork, weaving and crafts. Melrose, Natchitoches Parish, Louisiana." Marion Post Wolcott, July 1940.

PLATE 130. "Melrose, Natchitoches Parish, Louisiana. Son of one of the mulattoes who works on the John Henry plantation." Marion Post Wolcott, June 1940.

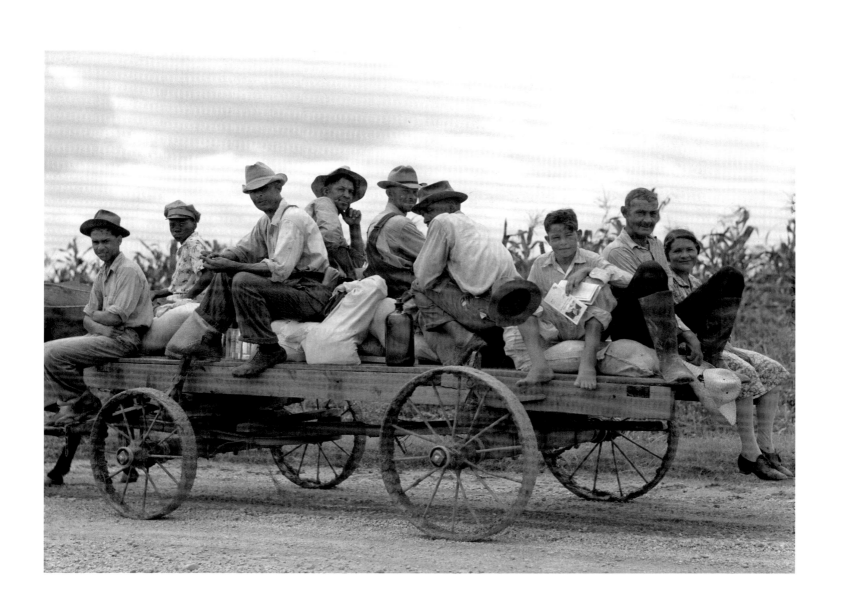

PLATE 131. "Mulattoes returning from town with groceries and supplies near Melrose, Natchitoches Parish, Louisiana." Marion Post Wolcott, July 1940.

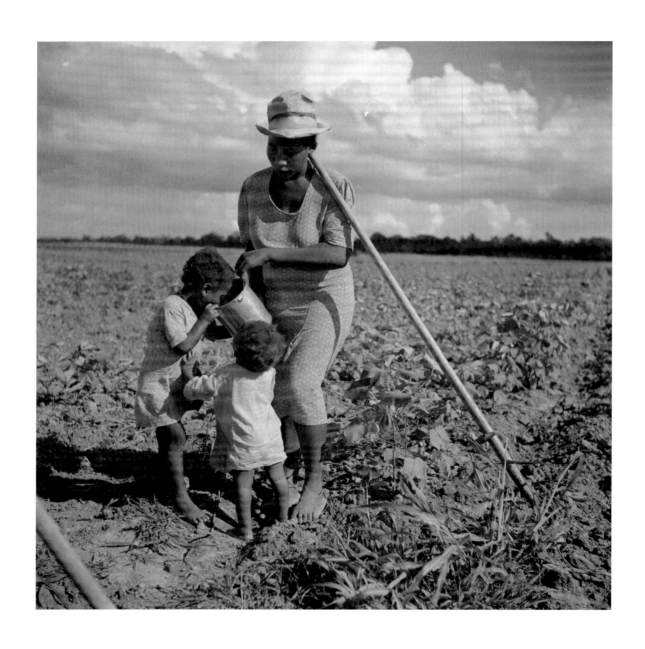

PLATE 132. "Member of Allen Plantation cooperative association resting while hoeing cotton. Near Natchitoches, Louisiana." Marion Post Wolcott, July 1940.

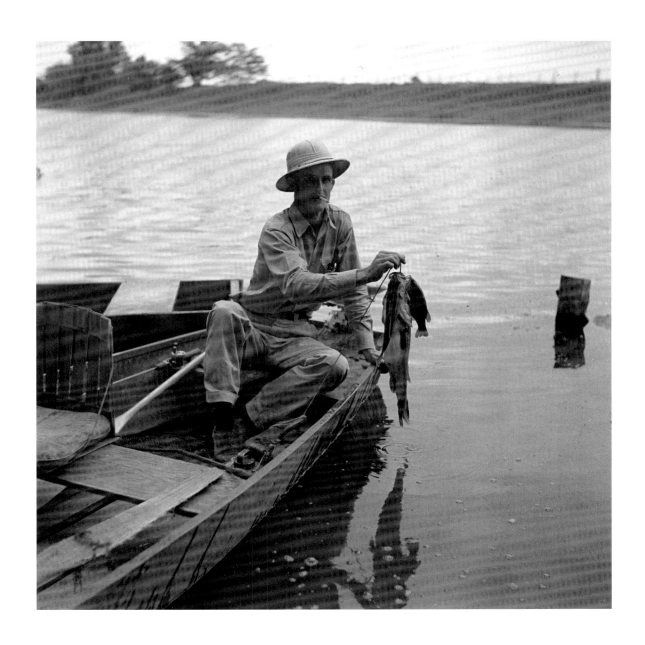

PLATE 133. "Boating and fishing along Cane River on Fourth of July near Natchitoches, Louisiana." Marion Post Wolcott, July 1940.

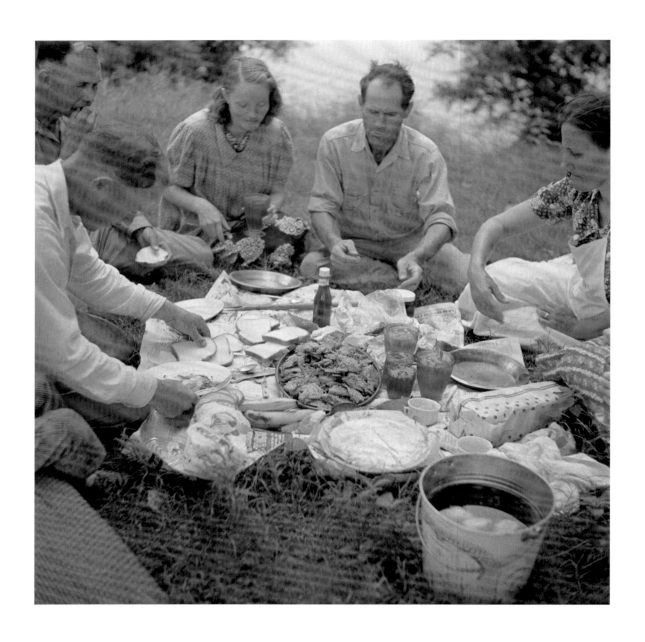

PLATE 134. "Farm family having fish fry on Fourth of July along Cane River. Near Natchitoches, Louisiana." Marion Post Wolcott, July 1940.

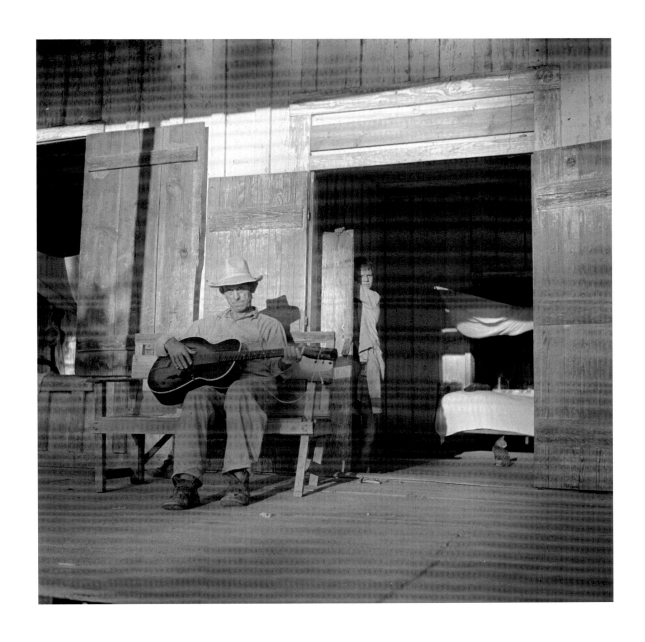

PLATE 135. "Farmer playing guitar on the porch in the evening. Near Natchitoches, Louisiana." Marion Post Wolcott, Aug. 1940.

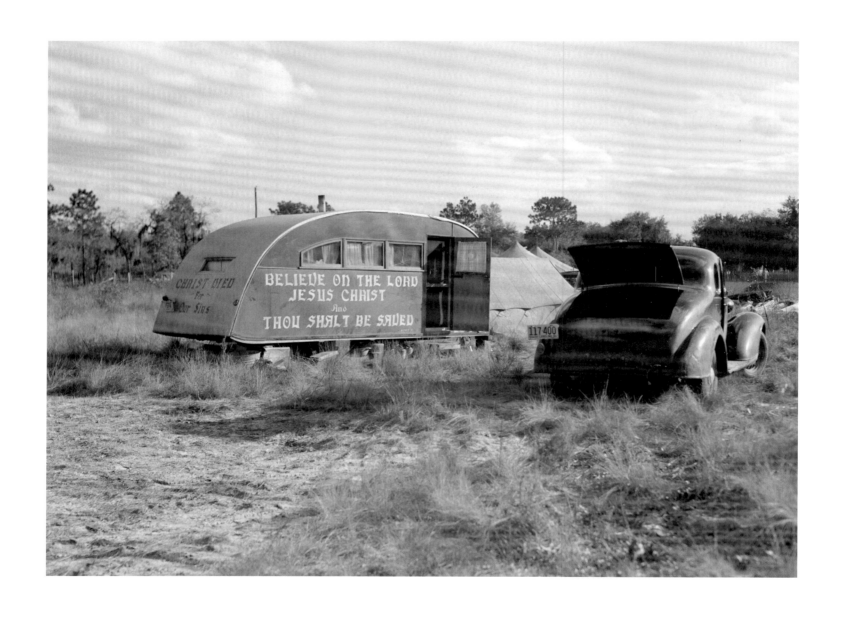

PLATE 136. "Itinerant preacher from South Carolina saving the souls of the construction workers at Camp Livingston job near Alexandria, Louisiana." Marion Post Wolcott, Dec. 1940.

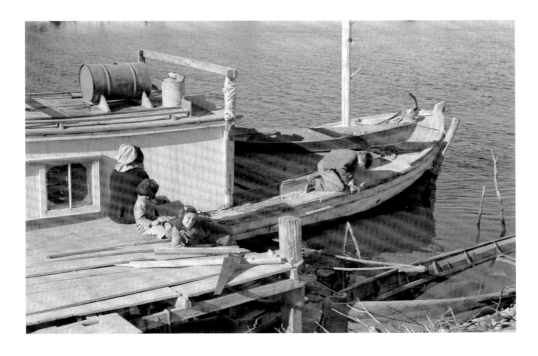

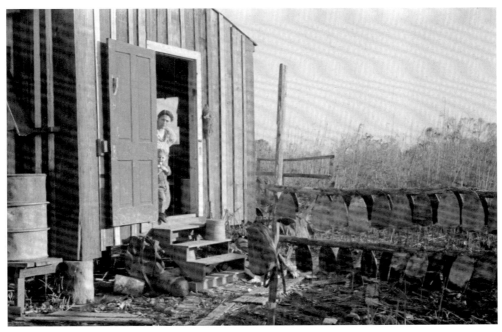

PLATE 137. "Spanish trapper's son repairing their boat which is used to go out to their camps in the marshes and for fishing and shrimping in other seasons. On Delacroix Island, Louisiana. See general caption no. 1." Marion Post Wolcott, ca. Jan. 1941.

PLATE 138. "Spanish trapper's wife and child in doorway of their camp. Stretched muskrat skins drying to the right. In the marshes near Delacroix Island, Louisiana. See general caption no. 1." Marion Post Wolcott, ca. Jan. 1941.

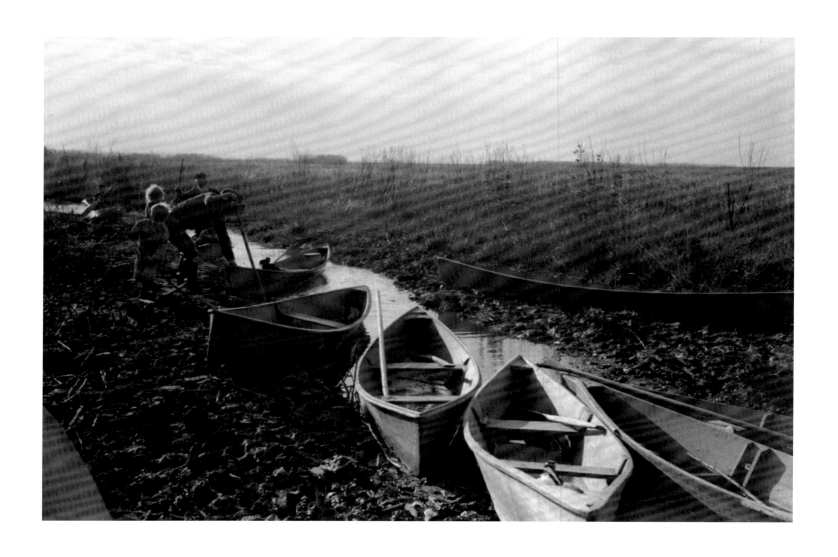

PLATE 139. "Spanish trappers returning in their home-built pirogues (canoes) in the evening after having made the rounds of their muskrat traps. In the marshes near Delacroix Island, Louisiana. See general caption no. 1." Marion Post Wolcott, ca. Jan. 1941.

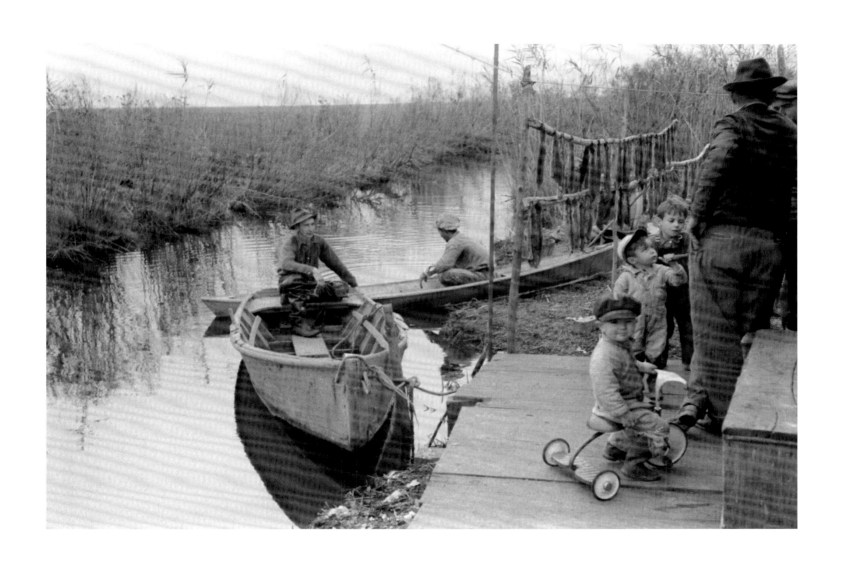

PLATE 140. "Spanish muskrat trappers camp near Delacroix Island, Louisiana." Marion Post Wolcott, 1940 or 1941.

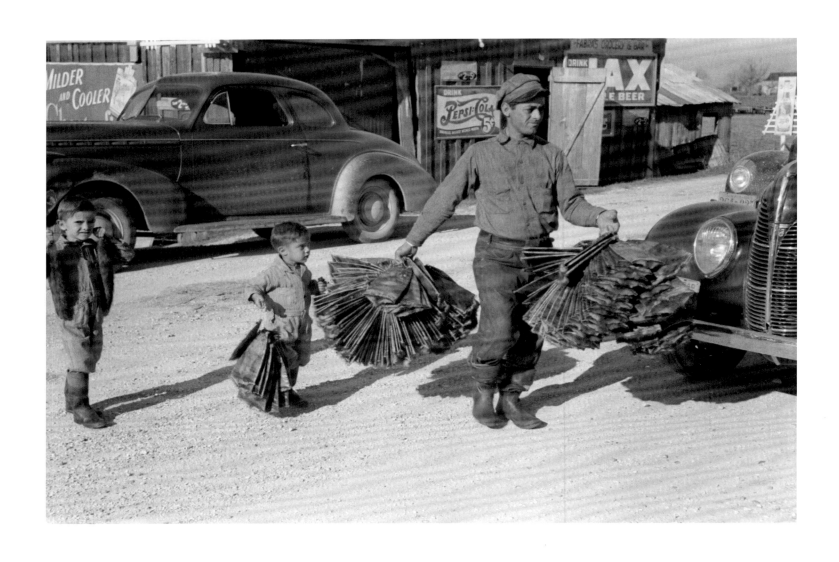

PLATE 141. "Spanish trapper and his children taking muskrat pelts into the FSA (Farm Security Administration) auction sale which is held in a dancehall on Delacroix Island, Louisiana. The fur buyers come from New Orleans." Marion Post Wolcott, ca. Jan. 1941.

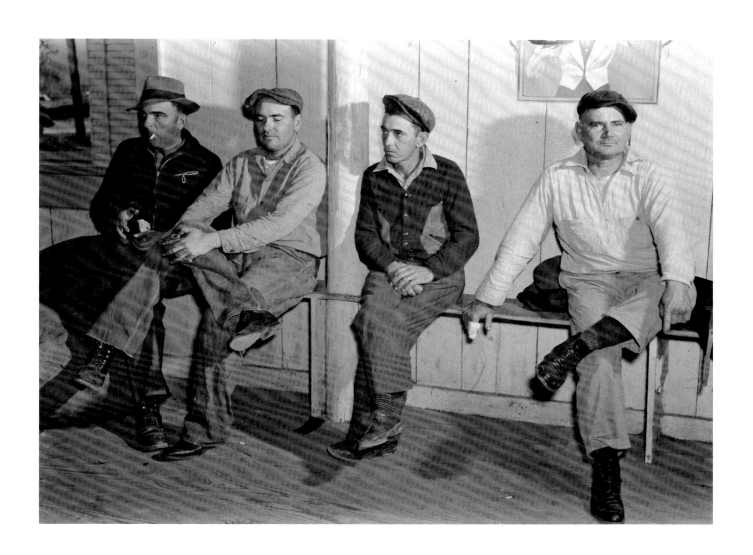

PLATE 142. "Spanish muskrat trappers waiting in dance hall during fur auction sale. Delacroix Island, Louisiana." Marion Post Wolcott, Jan. 1941.

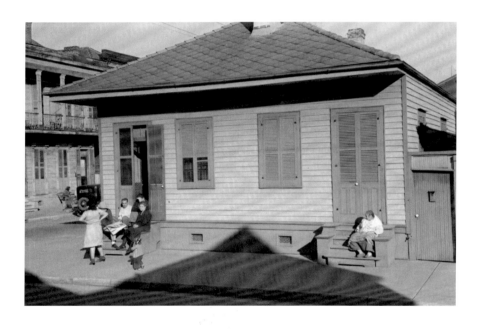

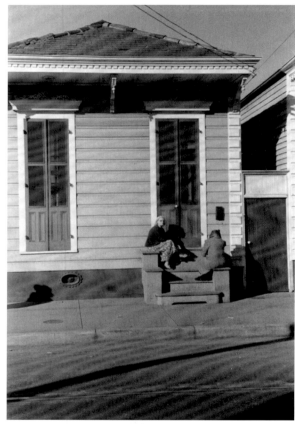

PLATE 143. "Untitled photo, possibly related to: Sunday afternoon in New Orleans, Louisiana." Marion Post Wolcott, ca. Jan. 1941.

PLATE 144. "Sunday afternoon in New Orleans, Louisiana." Marion Post Wolcott, ca. Jan. 1941.

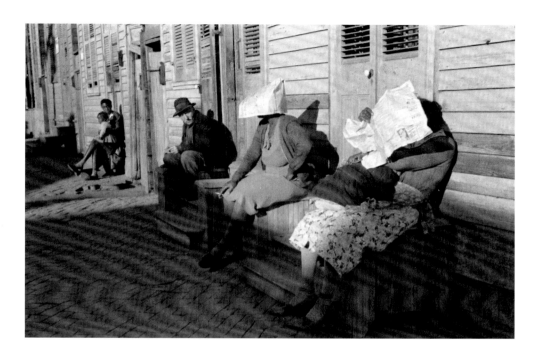

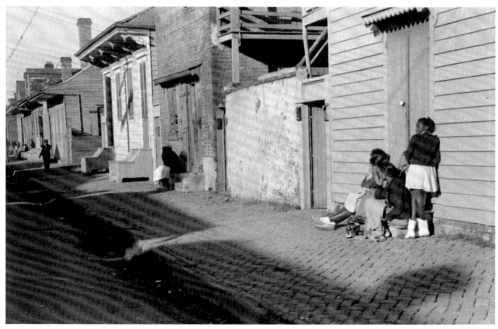

PLATE 145. "Sunday afternoon in New Orleans, Louisiana." Marion Post Wolcott, ca. Jan. 1941.

PLATE 146. "Untitled photo, possibly related to: Sunday afternoon in New Orleans, Louisiana." Marion Post Wolcott, ca. Jan. 1941.

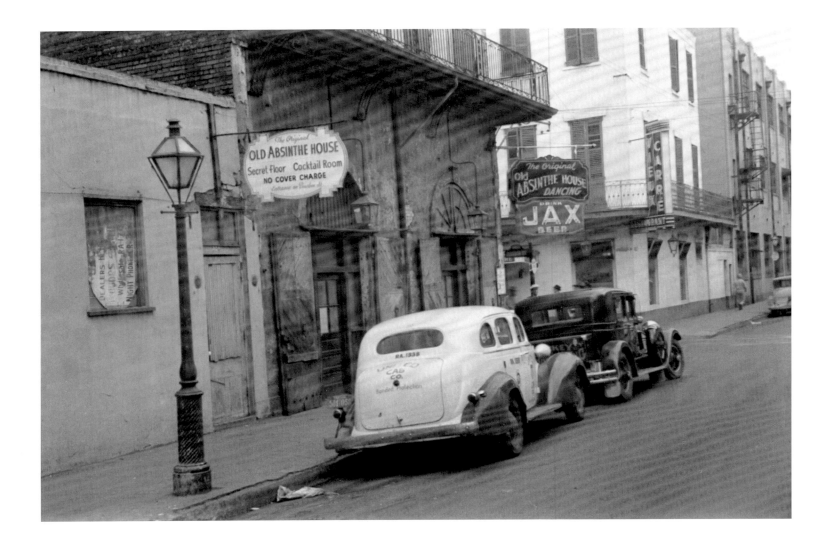

PLATE 147. "Old buildings in New Orleans, Louisiana." Marion Post Wolcott, ca. Jan. 1941.

APPENDIX
CASE FILE TRANSCRIPTIONS

Case Files

NEW DEAL AGENTS KEPT RECORDS of low-income farm applicants who applied for relief via a variety of programs. The multiplicity of programs means that the records today are distributed across federal, regional, and state depositories. The hub for many of the resettlement and aid case files is a records cluster documenting the Farmers Home Administration and its predecessors, in custody of the National Archives and Records Administration (Record Group 96), with major depositories for southern records in Fort Worth and Atlanta. The records were so extensive and often redundant that they were sometimes culled through sampling; the Atlanta group of the Rural Rehabilitation Loan Case Files (1934–44) alone contains 134 boxes.

These records remain an arguably underutilized resource for researchers. The National Archives recently identified their Rural Rehabilitation Loan Case Files and Farm Ownership Files Series as among "The Best National Archives Records Genealogists Aren't Using." Both case file transcriptions below are from federal case files duplicated in the Ben Shahn Papers. (See the National Archives Web site, www.archives. gov, for details on these and other case files.)

CASE FILE 1

TANGIPAHOA PARISH

JAMES TEMPLE (Col) AMITE

James Temple, 63, has lived near Amite, La. all his life, farming most of the time. During the good seasons he cleared money on his strawberry crops, and raised his feed for his mule, produced sufficient garden truck for his family's needs. During past two years the family has been on the Relief rolls. James worked as laborer, and later, as a farm owner, he was granted a loan through the Louisiana Rural Rehabilitation Corporation. Later this loan had to be cancelled because he did not secure sufficient plants, and did not prepare his ground for plants. It was necessary to take the fertilizer back to the Co-operative Association. As the man had failed to co-operate with the L.R.R.C., his case was held pending the repayment of advances made him.

James lives in a most dilapidated, three room house. The back room has no floor, the roof leaks like a seive [*sic*], the supports to the front of the house are broken, the whole house sags, the field has grown up in weeds.

James has developed a very bad case of rheumatism caused, supposedly, from drinking poisonous whiskey. He was sent to a physician for an examination, and the doctor said that James was really unable to work. The case then was referred to the Director of Parish Welfare Committee for the Unemployable because James would be ineligible for a strawberry loan this year.

HARLESTON/hgg

TANGIPAHOA PARISH

MRS. MARY FONTANA (white) INDEPENDENCE

The family first applied for Relief in July of 1933 as the man was very ill, having a cerrebreal [*sic*] cancer, and the other members of the family could no longer furnish money for treatment or food. Transportation to the hospital for radium treatment had been furnished by the Red Cross, but it could no longer furnish this and the local chairman referred the family to the E.R.A. Nobody in the family had any public work record, and the children were too young to work, so the case was rejected after investigation. The man died in September, but the family was able to secure a loan through a Co-operative association, but mortgaged the farm for $250.00.

In May, 1934 the family re-applied for assistance as their berry crop had not paid off their loan from the association and they were in great need of assistance. A daughter, Elizabeth, was seventeen years old and could work, being able to sew and do canning work very well. The family still owned their eleven acre farm, which was mortgaged, a mule, two cows, one calf, one hog, twenty chicken (not laying because of lack of proper feed) and sufficient farming implements for berry farming.

The family consisted of the mother and eight children, ranging in age from 2½ years to 19 years. The woman and her husband had both been born in Italy and had come to the U.S.A. when small children. The man was about ten years older than the woman. Neither of them had attended school. They had been married when the woman was only fourteen years old, and they made their home at Independence. There are six girls in the family. One of them, Angelina, 15, is totally blind as the result of typhoid fever when she was a small baby. Another of the girls is blind in one eye. Elizabeth, 17, was the applicant, and, as she was able to work, she was assigned to work in the Independence Canning Center, working on budgetary basis, from June 1st, 1934 to December 1st, 1934. During this time 75 cans and 25 quart jars were issued to the family and these were filled with beans, tomatoes, and okra for home use. The woman and a younger daughter were ill of malaria and medical care was provided.

In September, 1934, all farm owners were notified to make application for assistance through a private association, and failing to get this, then to apply for a loan thru the Louisiana Rural Rehabilitation Corporation. Mrs. Fontana made application and her loan was finally approved for sufficient fertilizer for 4 acres of berries and a minimum amount for subsistence for four months—or until the harvest of the berry crop was under way. The girls helped with the plowing, their grandfather and uncle helping with some of the hardest work. They set out 64,000 plants.

During the Winter their garden produced cabbage, mustard, kale, endive, fennel, and collards, and onions. They had plenty of sweet potatoes and pea vine hay.

Since the house was small and there were only 3 beds and insufficient covering, two of the children slept at their grandfather's house. The latter part of January, 1935, the garden produce was killed and the strawberries greatly damaged by the freeze, and it was necessary to give clients more garden seed, and also issue an order for 100 lbs. of Irish potato seed.

-2-

Client's mule had died, and it was now necessary to secure use of another work animal. They arranged to use the father-in-law's mule until they could buy another one for themselves.

The family was given an order for two cotton batts, twenty yards of quilt covering material, four sheets, and four pillow cases. These were secured from the commodity house. Later they were able to get canned, beef stew meat, canned beans, and powdered milk from the commodity house.

After the first week in April the family began to harvest their berry crop. Had the freeze in January not hurt their plants they would have been picking berries in March, but the crop was very short because the first crop had been killed. Throughout the month of April and part of May the family managed on the money earned from their picking and packing. After the harvest season was over, and as practically every cent had been applied to repayment of the L.R.R.C. loan, it was necessary for the client to be given other assistance and groceries.

In July the client was referred to the Resettlement Administration, and in August, September, and October received subsistence checks, pending the acceptance of the client for a loan. The family has now been accepted as a loan client, and will receive money for fertilizer, necessary insecticides, garden seed, and subsistence for the coming crop season.

HARLESTON/hgg

PHOTOGRAPH CREDITS

Unless otherwise indicating, all Figures and Plates are found in the Library of Congress, Prints and Photographs Division, FSA/OWI Collection.

FIGURES

1. LC-USF344-003487-ZB.

2. LC-USF33-011585-M5.

3. LC-USZ62-120969.

4. LC-USW3- 019997-C.

5. Courtesy of the Zeiss Company.

6. LC-DIG-ppmsca-05611.

7. LC-USF34- 001276-C.

8. LC-USF34-017778-E, Lot 1676.

9. LC-USF34- 017634-C, Lot 1676.

10. LC-USF33-002076-M1, Lot 1674.

11. LC-USF33-000623-M2, Lot 1680.

12. Library of Congress, Prints and Photographs Division, FSA/OWI Color Photographs LC-USW36-199.

13. LC-USW3-033962-D.

14. LC-USW3-022841-E, Lot 1680.

15. LC-USF33-006213-M1, Lot 1673.

16. LC-USF33-006159-M3, Lot 1673.

17. LC-USF33- 002058-M1, Lot 1674.

18. LC-USF34-053919-E.

19. LC-USF34-031938-D, Lot 1704.

20. LC-USF33-011653-M1, Lot 1683.

21. LC-USF33-011777-M3, Lot 1697.

22. LC-USF33-011777-M2, Lot 1697.

23. LC-USF34-009388-E, Lot 1680.

24. LC-USF33-011779-M5, Lot 1698.

25. LC-USF33-011845-M2.

26. LC-USF33-011889-M2, Lot 1690.

27. LC-USF33-011869-M1, Lot 1690.

PLATES

1. LC-USF33-006183-M2, Lot 1452.

2. LC-USF33-006099-M2, Lot 1680.

3. LC-USF33-006099-M5, Lot 1680.

4. LC-USF33-006097-M3, Lot 1680.

5. LC-USF33-006173-M2, Lot 1680.

6. LC-USF33-006183-M4, Lot 1680.

7. LC-USF33-006098-M2, Lot 1680

8. LC-USF33-006154-M3.

9. LC-USF33-006114-M5, Lot 1673.

10. LC-USF33-006157-M5, Lot 1673.

11. LC-USF33-006156-M2, Lot 1673.

12. LC-USF33-006159-M1, Lot 1673.

13. LC-USF33-006113-M4, Lot 1673.

14. LC-USF33-006216-M2, Lot 1673

15. LC-USF33-006212-M1, Lot 1673.

16. LC-USF33-006212-M4, Lot 1673.

17. LC-USF33-006174-M3, Lot 1673.

18. LC-USF33-006174-M2, Lot 1673.

19. LC-USF33-006175-M3.

20. LC-USF33-006208-M3, Lot 1673.

21. LC-USF33-006206-M3, Lot 1673.

22. LC-USF33-006209-M2, Lot 1673.

23. LC-USF33-011903-M3, Lot 1716.

24. LC-USF33-011803-M3, Lot 1679.

25. LC-USF33-011636-M1, Lot 1680.

26. LC-USF33-011622-M2, Lot 1684.

27. LC-USF33-011804-M3, Lot 1681.

28. LC-USF33-011812-M1, Lot 1681.

29. LC-USF33-011858-M3, Lot 1681.

30. LC-USF33-011613-M3.

31. LC-USF33-011791-M3, Lot 1677.

32. LC-USF33-011820-M2, Lot 1677.

33. LC-USF33-011792-M2, Lot 1677.

34. LC-USF33-011827-M3, Lot 1679.

35. LC-USF33-011826-M1, Lot 1678.

36. LC-USF33-011647-M2, Lot 1678.

37. LC-USF33-011645-M3, Lot 1678.

38. LC-USF33-011822-M1, Lot 1678.

39. LC-USF33-011645-M1, Lot 1678.

40. LC-USF33-011819-M2, Lot 1678.

41. LC-USF33-011823-M5, Lot 1678.

42. LC-USF33-011818-M3, Lot 1678.

43. LC-USF33-011817-M2, Lot 1663.

44. LC-USF33-011821-M4, Lot 1663.

45. LC-USF33-011821-M3, Lot 1678.

46. LC-USF33-011654-M5, Lot 1683.

47. LC-USF34-031396-D.

48. LC-USF33-011623-M1, Lot 1681.

49. LC-USF33-011623-M5, Lot 1681.

50. LC-USF33-011856-M4, Lot 1682.

51. LC-USF33-011702-M3, Lot 1716A.

52. LC-USF33-011702-M4, Lot 1716A.

53. LC-USF33-011862-M2, Lot 1691.

54. LC-USF33-011844-M3, Lot 1691.

55. LC-USF33-011862-M4, Lot 1691.

56. LC-USF34-031753-D, Lot 1691.

57. LC-USF33-011838-M3, Lot 1690.

58. LC-USF34-031787-D, Lot 1689.

59. LC-USF33-011883-M2, Lot 1689.

60. LC-USF33-011880-M5, Lot 1689.

61. LC-USF33-011848-M3, Lot 1691.

62. LC-USF33-011872-M3.

63. LC-USF33-011869-M3, Lot 1690.

64. LC-USF33-011837-M1, Lot 1690.

65. LC-USF33-011843-M1, Lot 1690.

66. LC-USF33-011849-M2, Lot 1691.

67. LC-USF33-011853-M2, Lot 1691.

68. LC-USF33-011842-M1.

69. LC-USF33-011659-M5, Lot 1694.

70. LC-USF33-011764-M5, Lot 1691.

71. LC-USF33-011903-M4, Lot 1663.

72. LC-USF33-011763-M4, Lot 1698.

73. LC-USF33-011763-M2, Lot 1663.

74. LC-USF33-011860-M2, Lot 1716-A.

75. LC-USF33-011649-M1.

76. LC-USF33-011628-M3, Lot 1693.

77. LC-USF33-011632-M3, Lot 1693.

78. LC-USF34-031666-D, Lot 1695.

79. LC-USF33-011707-M4, Lot 1695.

80. LC-USF33-011734-M1, Lot 1695.

81. LC-USF33-011741-M4, Lot 1695.

82. LC-USF34-031469-D, Lot 1695.

83. LC-USF34-031462-D, Lot 1695.

84. LC-USF33-011736-M4, Lot 1695.

85. LC-USF33-011716-M2, Lot 1695

86. LC-USF33-011738-M2, Lot 1695.

87. LC-USF33-011741-M5, Lot 1695.

88. LC-USF33-011740-M3, Lot 1695.

89. LC-USF33-011737-M3, Lot 1695.

90. LC-USF34-031453-D, Lot 1695.

91. LC-USF33-011760-M2, Lot 1696.

92. LC-USF33-011757-M5, Lot 1697.

93. LC-USF33-011901-M4, Lot 1687.

94. LC-USF33-011887-M5, Lot 1687.

95. LC-USF33-011892-M4, Lot 1687.

96. LC-USF33-011887-M2, Lot 1687.

97. LC-USF33-011875-M3, Lot 1687.

98. LC-USF33-011773-M2, Lot 1690.

99. LC-USF33-011903-M2, Lot 1691.

100. LC-USF33-011891-M2, Lot 1686.

101. LC-USF33-011899-M2, Lot 1688.

102. LC-USF33-011898-M4, Lot 1688.

103. LC-USF33-011890-M1, Lot 1686.

104. LC-USF33-011764-M1, Lot 1692.

105. LC-USF34-031811-D, Lot 1692.

106. LC-USF33-011810-M4, Lot 1663.

107. LC-USF33-011751-M5, Lot 1685.

108. LC-USF33-011755-M4, Lot 1685.

109. LC-USF33-011748-M4, Lot 1685.

110. LC-USF33-011781-M2, Lot 1685.

111. LC-USF33-011767-M1, Lot 1685.

112. LC-USF33-011769-M4, Lot 1685.

113. LC-USF33-011762-M4, Lot 1685.

114. LC-USF33-011768-M1, Lot 1685.

115. LC-USF33-011927-M3, Lot 1704.

116. LC-USF33-011929-M1, Lot 1704.

117. LC-USF34-031894-D, Lot 1704.

118. LC-USF33-012113-M1, Lot 1700.

119. LC-USF33-012115-M2, Lot 1700.

120. LC-USF33-012114-M4, Lot 1700.

121. LC-USF33-012164-M1, Lot 1701.

122. LC-USF33-012162-M2, Lot 0615.

123. LC-USF34-054015-D, Lot 1705.

124. LC-USF34-054327-E, Lot 1713.

125. LC-USF34-054247-D, Lot 1713.

126. LC-USF34-054451-E, Lot 1711.

127. LC-USF34-054492-E, Lot 1710.

128. LC-USF34-054544-E, Lot 1712.

129. LC-USF34-054932-E, Lot 1712.

130. LC-USF34-054543-E, Lot 1712.

131. LC-USF34-054698-D, Lot 1712.

132. LC-USF34-054481-E, Lot 1708.

133. LC-USF34-054457-E, Lot 1711.

134. LC-USF34-054464-E, Lot 1711.

135. LC-USF34-054519-E.

136. LC-USF34-056740-D, Lot 1716.

137. LC-USF33-031174-M3, Lot 1714.

138. LC-USF33-031185-M4, Lot 1714.

139. LC-USF33-031183-M2, Lot 1714.

140. LC-USF33-031271-M2, Lot 1714.

141. LC-USF33-031187-M1, Lot 1715.

142. LC-USF34-057298-D, Lot 1715.

143. LC-USF33-031178-M2, Lot 1680.

144. LC-USF33-031177-M2, Lot 1680.

145. LC-USF33-031191-M3, Lot 1680.

146. LC-USF33-031192-M5, Lot 1680.

147. LC-USF33-031189-M5, Lot 1680.

BIBLIOGRAPHY

"About the FSA/OWI Black and White Negatives." Prints and Photographs Reading Room, Library of Congress. www.loc.gov. Web. 13 Aug. 2016.

Adams, Jane, and D. Gorton. "This Land Ain't My Land: The Eviction of Sharecroppers by the Farm Security Administration." *Agricultural History* 83.3 (July 2009): 323–51. www.Jstor.org. Web. 12 Sept. 2016.

Barry, John M. *Rising Tide: The Great Mississippi Flood of 1927 and How It Changed America.* New York: Simon and Schuster, 1997. Print.

Ben Shahn papers, 1879–1990, bulk 1933–1970. Smithsonian Archives of American Art, Box 22, Folder 41 (correspondence with Roy Stryker) and Box 23, Folders 42–47 (USDA, FSA).

Bernard, Shane. *The Cajuns: Americanization of a People.* Jackson: UP of Mississippi, 2003. Print.

Biles, Roger. *The South and the New Deal.* 1994. Lexington: UP of Kentucky, 2006. Print.

Brannan, Beverly W. "To Make a Dent in the World." *FSA: The American Vision.* Eds. Gilles Mora and Beverly W. Brannan. New York: Abrams, 2006. 8–20. Print.

Brannan, Beverly W. "Marion Post Wolcott (1910–1990), A Biographical Essay." *Prints and Photographs Reading Room.* Library of Congress. 2012. www.loc.gov. Web. 14 Mar 2016.

Brasseaux, Carl A. *French, Cajun, Creole, Houma: A Primer on Francophone Louisiana.* Baton Rouge: Louisiana State UP, 2005. Print.

Conkin, Paul, and Betty Field. "Louisiana Gothic: Recollections of the Thirties." Eds. Glenn R. Conrad and Vaughan B. Baker. *Cultural Vistas* (Spring 1994): 38–49. Print.

Dablow, Dean. *The rain are fallin': A Search for the People and Places Photographed by the Farm Security Administration in Louisiana, 1935–1943.* Tollhouse, CA: Scrub Jay Press, 2001. Print.

Daniel, Pete. "Reasons to Talk about Tobacco." *Journal of American History* 96.3 (Dec. 2009): 663–77. Web. 14 Mar 2017.

Davis, Keith E. *Photographs of Dorothea Lange.* New York: Harry N. Abrams, 1996.

Din, Gilbert C. *The Canary Islanders of Louisiana.* Baton Rouge: Louisiana State UP, 1988.

Elek, Mike. "Zeiss Ikon Super Ikonta 530/2: Living Large." *A Classic Camera Profile.* www.elekm.net. Web. 13 Sept. 2015.

Ellenberg, George. *Mule South to Tractor South: Mules, Machines, and the Transformation of the Cotton South.* Tuscaloosa: U of Alabama P, 2007. Print.

Ellzey, Bill. "Hassles Plagued Schriever Farming Project over the Years." *Daily Comet* 30 May 2007. www.dailycomet.com. Web. 13 Sept. 2016.

"Farm Security Administration/Office of War Information Written Records: Selected Documents." Prints and Photographs Reading Room, Library of Congress. www.loc.gov. Web. 11 July 2016.

Fineman, Mia. "Kodak and the Rise of Amateur Photography." In *Heilbrunn Timeline of Art History.* New York: The Metropolitan Museum of Art, 2000. www.metmuseum.org. Web. 7 July 2016.

Fleischhauer, Carl, and Beverly W. Brannan. "Introduction." *Documenting America, 1935–1943.* Eds. Carl Fleischhauer and Beverly W. Brannan. Berkeley, U of California P, 1988. 1–13. Print.

Fleischhauer, Carl, and Beverly W. Brannan, eds. *Documenting America, 1935–1943.* Berkeley, U of California P, 1988. Print.

"FSA-OWI Photographic Prints." Prints and Photographs Reading Room, Library of Congress. www.loc.gov. Web. 13 Aug. 2016.

Gaines, Ernest. *Catherine Carmier.* 1964. New York, Vintage Books, 2012. Print.

——. *A Gathering of Old Men*. 1983. New York: Vintage Books, 1992. Print.

Ganzel, Bill. *Dust Bowl Descent*. Lincoln: U of Nebraska P, 1984. Print.

Greenfeld, Howard. *Ben Shahn: An Artist's Life*. New York: Random House, 1998. Print.

Harriet L. Herring Papers #4017, Southern Historical Collection, The Wilson Library, University of North Carolina at Chapel Hill.

Hendrickson, Paul. *Looking for the Light: The Hidden Life and Art of Marion Post Wolcott*. New York: Knopf, 1992. Print.

Hill, John T. *Signs of Life*. Göttigen, Germany: Steidl, 2010. Print.

Howard Washington Odum Papers #3167, Southern Historical Collection, Wilson Library, University of North Carolina at Chapel Hill.

Hudson, Berkley. "O. N. Pruitt's Possum Town: The 'Modest Aspiration and Small Renown' of a Mississippi Photographer, 1915–1960." *Southern Cultures* 13.2 (2007): 52–77. Print.

Hurley, F. Jack. *Marion Post Wolcott: A Photographic Journey*. Albuquerque: U of New Mexico P, 1989. Print.

——. *Portrait of a Decade: Roy Stryker and the Development of Documentary Photography in the Thirties*. Baton Rouge: Louisiana State UP, 1972. Print.

——. *Russell Lee, Photographer*. New York: Morgan and Morgan, 1978. Print.

Kahn, Eve M. "Finding the Other America in Slums and on Farms." *New York Times* 3 June 2010. www.nytimes.com. Web. 13 Sept. 2016.

Mellow, James R. *Walker Evans*. New York: Basic Books, 2001. Print.

Miller, Robin. "Photographer Fonville Winans Captured History, Hard Times." *The Advocate* 26 May 2014. www.theadvocate.com. Web. 7 July 2016.

Mills, Gary B. *The Forgotten People: Cane River's Creoles of Color*. Baton Rouge: Louisiana State UP, 1977. Print.

Mitchell, Brent. "Capturing the Ordinary: Russell Lee in Southeastern Louisiana." Thesis. U of Louisiana at Lafayette, 2004. Print.

Mora, Gilles, and Beverly W. Brannan, eds. *FSA: The American Vision*. New York: Abrams, 2006. Print.

Otis Noel Pruitt and Calvin Shanks Photographic Collection #05463, Southern Historical Collection, The Wilson Library, University of North Carolina at Chapel Hill.

Parr, Leslie Gale. "Theodore Fonville Winans." In *KnowLA Encyclopedia of Louisiana*. Ed. David Johnson. Louisiana Endowment for the Humanities, 25 Jan. 2011. Web. 7 July 2016.

Photogrammar. photogrammar.yale.edu. Yale University. Web. 11 Apr. 2015.

Plattner, Steven. *Roy Stryker: USA 1943–1950*. Austin: U of Texas P, 1983. Print.

Raynor, Vivien. "The Compassion of Peter Sekaer." *New York Times* 14 Nov. 1982. www.nytimes.com. Web. 13 Sept. 2016.

Rathbone, Belinda. *Walker Evans: A Biography*. New York: W. W. Norton, 1995. Print.

Rothstein, Arthur. "Oral history interview with Arthur Rothstein." Interviewed by Richard Doud 25 May 1964. www.aaa.si.edu. Archives of American Art, Smithsonian Institute. Web. 20 May 2015.

"Roy Stryker on FSA, SONJ, J&L." Interviewed by Robert J. Doherty, F. Jack Hurley, Jay M. Kloner, and Carl G. Ryant. 1972. *Image* 18.4 (Dec. 1975): 1–18. Copies of the original transcript and interview tapes are available through the Oral History Center, History Department, University of Louisville.

Roy Stryker Papers [microfilm]. Middleton Library, LSU. LSU Microfilm Reels (reels 1 and 2). Accessed July 2014.

Roy Emerson Stryker papers [microfilm], 1932–1964, Archives of American Art, Smithsonian Institution. AAA Microfilm Reel (reel 30). Accessed December 2014–February 2015.

Scott, John H., with Cleo Scott Brown. *Witness to the Truth: My Struggle for Human Rights in Louisiana*. Columbia: U of South Carolina P, 2003. Print.

Shahn, Ben. "Oral history interview with Ben Shahn." Interviewed by Richard Doud 14 Apr. 1964. www.aaa.si.edu. Archives of American Art, Smithsonian Institute. Web. 13 Aug. 2014.

Sontag, Susan. *On Photography*. 1973. New York: Picador, 2011. Print.

Vetter, Cyril E. *Fonville Winans' Louisiana: Politics, People, and Places*. Baton Rouge: Louisiana State UP, 1995. Print.

Winans, Fonville. *Cruise of the Pintail*. Baton Rouge: Louisiana State UP, 2011. Print.

Wolcott-Moore, Linda. "Marion Post Wolcott." www.people.virginia.edu. University of Virginia, 1999. Web. 30 June 2015.

INDEX